Impressionist Paintings Drawings and Sculpture

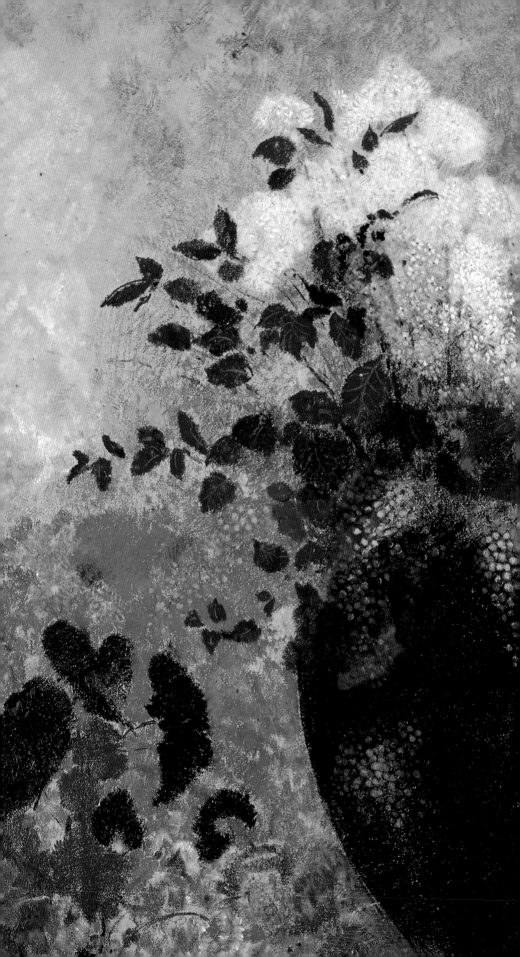

Impressionist Paintings Drawings and Sculpture

from the
Wendy and Emery Reves
Collection

Richard R. Brettell

Julie Lawrence Cochran, Research Assistant
Tom Jenkins, Photographer

DALLAS MUSEUM OF ART

This handbook was made possible by the Dallas Museum of Art League.

Edited by Queta Moore Watson, with assistance from Patricia Draher
Designed by John Hubbard

Produced by Marquand Books, Inc., Seattle

Printed and bound by C & C Offset Printing, Hong Kong

Library of Congress Cataloging-in-Publication Data
Brettell, Richard R.
 Impressionist paintings, drawings, and sculpture from the Wendy and Emery Reves collection / Richard R. Brettell ; Julie Lawrence Cochran, research assistant ; Tom Jenkins, photographer.
 p. cm.
 Includes bibliographical references.
 ISBN 0-936227-15-X (paper)
 1. Impressionism (Art)—Catalogs. 2. Reves, Wendy, 1916– —Art collections—Catalogs. 3. Reves, Emery, 1904–1981—Art collections—Catalogs. 4. Art—Private collections—Texas—Dallas—Catalogs. 5. Dallas Museum of Art—Catalogs. I. Dallas Museum of Art. II. Title.
 N6465.14B74 1995
 709'.03'440747642812—dc20 95-22832

Cover: Manet, *Vase of White Lilacs and Roses* (detail), p. 88.
Frontispiece: Redon, *Flowers in a Black Vase* (detail), p. 140.
Page 14: Renoir, *The Seine at Châtou* (detail), p. 56.

Contents

Dedicated to the
memory
of
Emery Reves

List of Artists in the Collection

Pierre Bonnard (1867–1947)

Jean-Baptiste Carpeaux (1827–1875)

Paul Cézanne (1839–1906)

Jean-Baptiste-Camille Corot (1796–1875)

Gustave Courbet (1819–1877)

Honoré Daumier (1808–1879)

Edgar Degas (1834–1917)

Henri Fantin-Latour (1836–1904)

Paul Gauguin (1848–1903)

Vincent van Gogh (1853–1890)

Johan Barthold Jongkind (1819–1891)

Maximilian Luce (1858–1941)

Edouard Manet (1832–1883)

Claude Monet (1840–1926)

Adolphe Monticelli (1824–1886)

Berthe Morisot (1841–1895)

Louis Osman (born 1914)

Camille Pissarro (1830–1903)

Odilon Redon (1840–1916)

Pierre-Auguste Renoir (1841–1919)

Auguste Rodin (1840–1917)

Ker Xavier Roussel (1867–1944)

Théo van Rysselberghe (1862–1926)

Georges Seurat (1859–1891)

Alfred Sisley (1839–1899)

Graham Sutherland (1903–1980)

Henri de Toulouse-Lautrec (1864–1901)

Maurice de Vlaminck (1876–1958)

Edouard Vuillard (1868–1940)

Foreword

Wendy Reves entered the life of the Dallas Museum of Art at a most propitious moment. Under the directorship of Harry Parker, the Dallas Museum of Art had already set its sights on enriching the artistic life of this vigorous and ambitious city. Plans were well underway for the move from Fair Park into stylish new facilities downtown. The moment could not have been more appropriate for the meeting of patron and museum director that was to be of such immense importance to this community. The bond that formed between these two remarkable people, Wendy Reves and Harry Parker, culminated in the astonishing gift to the DMA that is chronicled in this volume and its companion volume on the decorative arts. It is now ten years since the Reves galleries first opened and the fortunes of this museum took a decided turn. Therefore, with profound gratitude, we celebrate that signal event with two handsome publications and the accompanying exhibition of the most significant and stellar objects in the Wendy and Emery Reves Collection.

Thanks are due to Charles L. Venable, Chief Curator and Curator of Decorative Arts, who served as project head; to Richard R. Brettell, who succeeded Harry Parker as director in Dallas, for his authorship of the entries; to Julie Lawrence Cochran, for her efforts as research assistant; to Debra Wittrup, who coordinated the project; to Queta Moore Watson, for the many hours she spent in her role as editor; and to Tom Jenkins, for his exceptional photography. Finally, the timely and generous financial assistance of the Dallas Museum of Art League was essential to the successful completion of this noteworthy project.

Ultimately, however, it is to Emery and Wendy Reves that this effort must be dedicated. We cannot but admire the extraordinary devotion of this couple in assembling such a distinguished group of pictures, drawings, and sculpture, much less the extreme generosity that moved Wendy to empty her beloved Villa La Pausa of its contents so as to enrich the citizens of Dallas. Her name must join the ranks of those distinguished museum patrons who have changed the course of institutions and forever nourished the lives of countless museum visitors.

Jay Gates
Director
Dallas Museum of Art

THE REVES COLLECTION

Introduction to the Paintings, Drawings, and Sculpture

Stories about the Reves Collection are legion—and many of them are untrue. I remember being told by several informed sources that Emery Reves was a passionate collector of impressionist and post-impressionist paintings and drawings in the 1930s and that by the time he met his future wife, Wendy Russell, in the late 1940s he had already amassed most of the collection that today bears his name. At that point—as the story goes—Villa La Pausa, in southern France, was purchased as their permanent home, and the Reveses switched their collecting direction from paintings and drawings to the decorative arts. The reasoning for this seemed logical: one must, after all, furnish a large house, and Wendy Russell Reves was—and is—more interested in the decorative arts than in paintings.

Yet, like many other stories that swirl around the Reveses, this one is in error. Emery Reves did buy several important paintings in the late 1930s and during the 1940s, but by far the greater part of the collection was acquired gradually throughout the 1950s and 1960s, when works of art were more readily available than before the war and there was more than sufficient wall space in the vast rooms of the villa to display these works of art. This fact of the gradual acquisition of the collection is crucial for our analysis of its importance and because it suggests that Wendy Reves was as actively involved in the collection of paintings and drawings as she was with the furniture, porcelain, fans, rugs, glass, and metalwork.

Emery Reves began collecting important paintings and antique frames in order to decorate and personalize the series of hotel suites in which he lived before the acquisition of Villa La Pausa. As a multilingual eastern European, Reves was as cosmopolitan as any European of his generation. He was equally comfortable with English, French, and German and could function in a half-dozen other languages. His quick mind, interest in people, and research skills, derived from rigorous German university training, enabled him single-handedly to develop a network of journalists and experts that led to the creation of the first viable wire service in Europe, and his linguistic skills enabled him to become a global publisher before others attempted such a feat.

Like many educated people of his generation, Reves believed passionately in the importance of high culture and was keenly interested in and

knowledgeable about the visual arts. Unlike many collectors of the mid-20th century, he developed a major research library and consulted scores of important scholars and dealers in his search for increasingly important works of art. Also unlike other collectors, he continued to solicit information about works already in his collection, enriching his mind—and his files—as new discoveries were made, visiting and lending to important exhibitions as often as he could, and adding new books and catalogues to his library.

He was also completely at home in the various artistic capitals of Europe as well as in New York, and he was received instantly by the greatest art dealers in London, Paris, and Zurich, and in smaller cities with less international markets. For this reason, he differed from other collectors, who preferred to develop a close relationship with one or two trusted dealers. Reves, with the assistance and advice of Wendy Reves, made all the decisions, choosing works from multiple sources and accepting the informed opinions of numerous great connoisseurs.

The research files prepared by Wendy and Emery Reves came with their library to the Dallas Museum of Art, making the gift of works of art even more valuable and important. The files contain fascinating letters from scholars like John Rewald and Douglas Cooper, letters indicating that these men were not paid advisors of the Reveses but were friends and colleagues who proffered advice and information out of respect for Reves, his taste, and his knowledge. The Reveses were frequent guests of the Rewalds at their villa in Ménèrbes, and both Rewald and Cooper were guests of the Reveses at La Pausa. Hence, for Reves, the slow, gradual appreciation of a work of art was an act enriched by lengthy discussion with the foremost authorities of his time. Such ambitions are rare in the history of modern collecting, and few Americans—one thinks immediately of James and Lillian Clark in Dallas, Joseph Pulitzer in St. Louis, or John and Dominique de Menil in Houston—can claim as great an integration of collecting, scholarship, and deep appreciation as that accomplished by Wendy and Emery Reves.

But Rewald and Cooper were not alone. Emery Reves was a restless correspondent, writing to the descendants of sitters in his portraits by Renoir and Bonnard or badgering Lionello Venturi, François Daulte, and K. E. Maison for information about his works by Cézanne, Pissarro, Renoir, and Daumier. Emery Reves was never content simply to file the information sheet from the dealer and then enjoy the picture passively. For him, knowledge was an integral part of aesthetic appreciation; aesthetics was serious and rewarding work. In certain cases, Reves proved himself a better and more logical art historian than his professional correspondents, and he relished correcting misinformation or arguing a point of attribution

or interpretation. His library is filled with well-worn books, which he read carefully and used frequently in his quest for knowledge or in an effort to prove a point. How one would like to have been at lunch with Wendy and Emery Reves when John Rewald, Graham Sutherland, Lionello Venturi, Winston Churchill, or Gerald van der Kemp were their guests. Then, the food and wine were the prelude to a discussion about works of art, a discussion in which books and photographs played as great a role as they do in a graduate seminar at Harvard, Yale, or the Courtauld Institute.

Even the Reves files contain treasures: letters to and from Douglas Cooper and the family of Lise Tréhot, who was the subject of two superb portraits by Renoir that were acquired from the descendants of the sitter; a unique document that records a visit to Cézanne's studio in the years before the painter's death; and other small delights. Yet, the primary "document" in our quest for an understanding of Wendy and Emery Reves as collectors is the works of art themselves.

There are, of course, the masterpieces—the Renoirs, the Gauguins, the Vlaminck, the late Manet still lifes, the Degas pastels, and the great works on paper by Cézanne, van Gogh, and Toulouse-Lautrec. And in the midst of these glories—works that would be hung in any museum in the world— there are wonderful discoveries that prove the Reveses were interested in a whole range of artworks: in drawings as well as paintings, in the perfectly resolved painting that is not quite typical of the artist, and in the unusual painting that sums up an artist. In the first category are the superb drawings by Renoir, Pissarro, and Manet. In the second are the strange panel painting by Degas, the sublime waterscape by Morisot, and the three small panels of 1890s Paris by Vuillard and Bonnard. For works that act as summaries of a career, I think immediately of Corot's delightfully modest portrait of his sister, Mme Sennegon, who sits quietly, her hands folded, in front of a beige painted wall. How pleased—and surprised—she would be to find herself housed in one of the most splendid aristocratic frames from the reign of Louis XV.

It is rhymes among works of art that make a group of paintings and drawings into a collection, and the Reves Collection abounds in rhymes. Landscapes by Morisot, Redon, and Seurat from the same years reveal the depth and variety of French landscape practice in that decade. The watercolors by Jongkind, Manet, Renoir, Pissarro, and Cézanne remind us that this most English of mediums wasn't moribund in France. And there are glorious pencil drawings, whether dashed off, as in the case of Vuillard, or carefully described, as in van Rysselberghe. There is also a love of the French rural landscape—a love that must have been assiduously sought by two very different foreigners—Wendy and Emery Reves. We walk along the Seine with Sisley, stare at a farm in Brittany with Gauguin, marvel at the

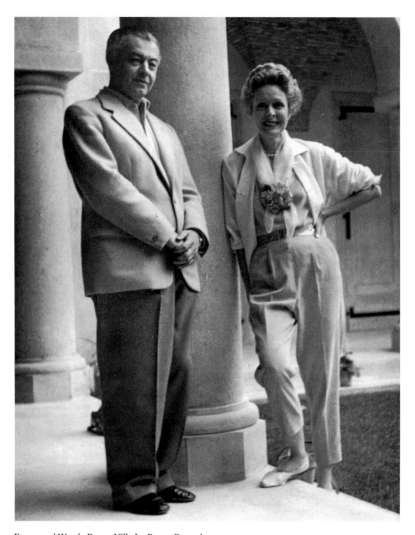

Emery and Wendy Reves, Villa La Pausa, Roquebrune,
Cap Martin, France, c. 1956

simple grandeur of a deserted farmhouse by Cézanne, and revel in the pastel subtlety of a morning just outside Paris with Pissarro. And the still lifes—by Manet, Redon, Courbet, Bonnard, Monticelli, and Cézanne—cannot be easily dismissed. The simple good life of the French table was celebrated not only in the dining room and kitchen of La Pausa but on the walls of its wonderfully proportioned rooms.

When one remembers that both Emery Reves and Wendy Reves were born into the lower-middle classes on two different continents, into two different religions, and speaking two different languages, the difficulties—and the sheer brilliance—of their "collective collections" become clear. These works were not simply bought; rather, they were gradually acquired, housed, and loved in a setting that neither Wendy nor Emery Reves could ever have imagined as children. Each acquisition was an adventure, and each object added to the ambience of La Pausa, an ambience that was a setting for reading, walking, dining, and conversations stimulated by the presence of works by Courbet, Manet, Pissarro, Bonnard, Vuillard, van Gogh, Rodin, and Sutherland. This book pays tribute to the collectors who learned, through buying, looking, and relooking, the lessons not only of art but of life.

Dr. Richard R. Brettell
Harvard University

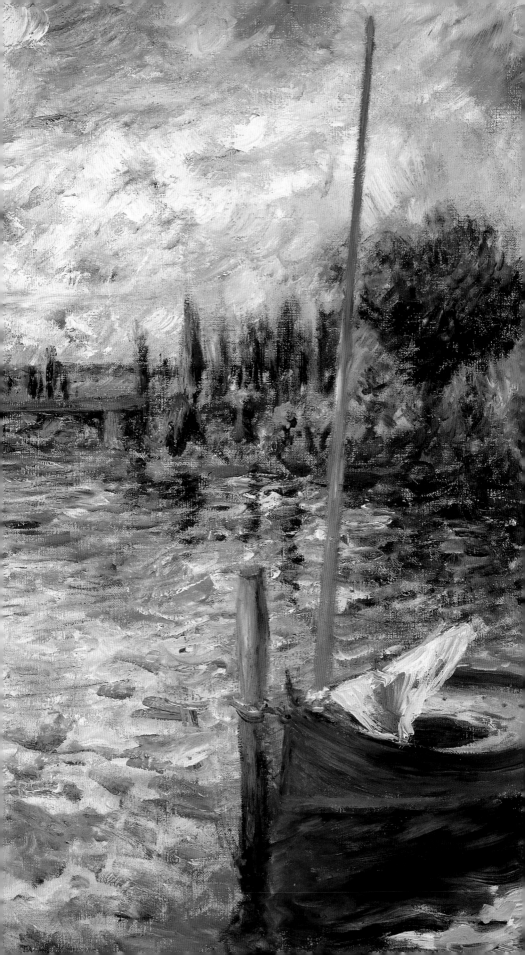

Catalogue

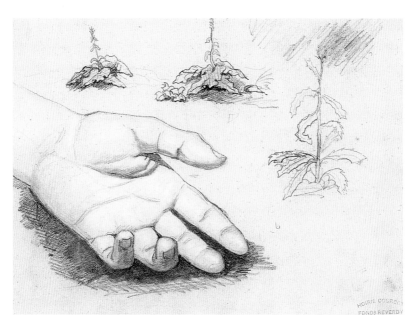

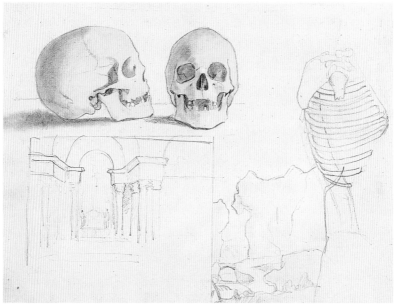

GUSTAVE COURBET

Study of a Hand, Thistle Plants (recto);
*Studies of Skulls, Skeleton, Baroque Church
Interior, and a Cliff* (verso), c. 1840–1842
Pencil on wove paper; 8¼ × 11⁷⁄₁₆ in. (21 × 29 cm)
Inscribed on recto, lower right: *HOIRIE
COURBET/Fonds Reverdy*
1985.R.20

GUSTAVE COURBET WAS neither a prolific nor a masterful draftsman, and with the exception of a few highly finished charcoal drawings of the 1850s and 1860s, the majority of his surviving drawings were in sketchbooks made during his youth. This double-sided drawing is probably a sheet from a dismembered sketchbook made in the early 1840s. The various studies on both sides are correctly rather than brilliantly drawn and include a wide range of subjects in a manner familiar to art historians who have looked at 19th-century art-student notebooks. Studies similar to Courbet's of a skeleton (the skull and the rib cage) could be found in comparable notebooks by hundreds of his contemporaries, and even the compelling study of a hand accords well with established drawing practice among students.

The hand is drawn precisely and represented fully to scale. It is the artist's own left hand, in a carefully observed pose that Courbet never again used in his art. Courbet was among the most self-absorbed artists in the history of French art, and he began to make self-images while in his early twenties. Most of them show a fascination with theatrical poses and elaborate hand gestures. By contrast, this simple study represents the hand almost as an inert still-life element. We are encouraged to think of the hand not as an "organ" of touch, but rather as an available "model" for the youthful artist.

The drawing has the stamp of the collection of Paul Reverdy, the grandson of the painter's younger sister, Zoe Courbet. It was purchased by Emery and Wendy Reves in 1967 from the Marseilles dealer Charles Garibaldi. The verso of the paper is tinged pink, suggesting that the recto was originally this color but has faded from exposure to light.

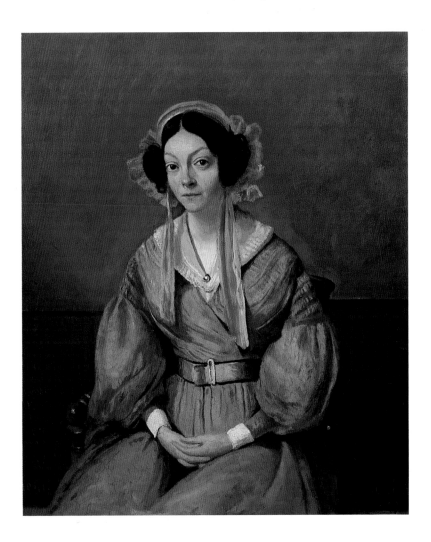

JEAN-BAPTISTE-CAMILLE COROT
Portrait of Mme Sennegon, the Artist's Sister, 1841
Oil on canvas; 18½ × 13 in. (46 × 33 cm)
Signed and dated, lower right: *C Corot 1841;*
dated, lower left: *1841*
64.1985

JEAN-BAPTISTE-CAMILLE COROT was
the greatest French landscape painter
of the 19th century. His career spanned
more than fifty years, from his trips to
Italy in the 1820s until his death in 1875.
Like Poussin before him and Cézanne
after him, Corot also made important
contributions to figure painting. Among
his least-known figure paintings are
the portraits, of which *Portrait of Mme
Sennegon* is among the very finest. Corot
never married and, perhaps as a conse-
quence, spent much of his life within
the protective circle of his family. He
remained close to his parents until their
death, and his warm relationship with his
sister Mme Sennegon extended through-
out his life and included her children,
their partners, and their children in turn.
One could easily assemble an exhibition
of portraits of every member of Corot's
extended family (see figs.), a statement
that can be made for very few great art-
ists of the past two centuries.

Jean-Baptiste-Camille Corot, *Portrait of Madame Charmois (Claire Sennegon)*, 1837. Oil on canvas, 16½ × 13⅜ in. (41.9 × 34 cm). Musée du Louvre, Paris. Photograph courtesy Réunion des Musées Nationaux.

Jean-Baptiste-Camille Corot, *Portrait of Mademoiselle Laure Sennegon*, 1831. Oil on canvas, 11¼ × 8½ in. (28.6 × 21.6 cm). Musée du Louvre, Paris. Photograph courtesy Réunion des Musées Nationaux.

The Reves portrait of Mme Sennegon was done when the painter's older sister was forty-eight years old, had been married for nearly twenty-eight years, and had borne seven children. Interestingly, Annette Octavie Corot's husband, Laurent Denis Sennegon, was in a way Corot's own adopted brother. The painter had lived with the Sennegon family in Rouen while attending school between 1807 and 1812. Thus, his favorite sister married his guardians' son, producing a family in which the shy artist felt completely at home.

Corot's portrait of his sister is an utterly bourgeois image. She confronts the painter/viewer with a simple direct-ness and "poses" without affectation. For her costume, she wears a simple though beautifully made dress, a single large pearl pin, and a delightful daytime hat that responds to the form of her hair. The silk ribbon, instead of being tied around her neck, falls in simple lines down the front of her costume, again as if to emphasize the simplicity and intimacy

of the portrait. The interior in which she is placed is totally plain, and the simple chair rail and a turned wooden chair are all that relieves the beige continuum of the room. If the portrait embodies virtues, they are bourgeois virtues— modesty, respectability, subtlety, and refinement. Nothing tells us that Mme Sennegon read books, looked at pic-tures, understood the opera, or played any role in family business affairs. We don't even have a clue about her mar-riage (no ring) or children (no toys or lockets). Instead, she confronts us calmly alone.

Corot painted his brother-in-law, Laurent Denis Sennegon (Museu de Arte, São Paulo), the next year, but de-cided to make the portrait on a small canvas, ensuring that it would not be hung as a pair with the portrait of his sister. We may never know whether this decision tells us about the sitters' respective importance to Corot or to each other.

GUSTAVE COURBET
Portrait of Régis Courbet,
the Artist's Father, c. 1848–1849
Watercolor and pencil on wove paper;
4⅛ × 4⅛ in. (10.5 × 10.5 cm)
Not signed or dated; corners cut to fit
circular format
1985.R.19

ALTHOUGH THE AUTHENTICITY of this drawing has never been questioned, there is considerable dispute about the identity of the man in both this watercolor and the oil painting to which it has a direct relationship. The painting, now in the Musée Courbet in the painter's hometown of Ornans, has been catalogued as a portrait of Courbet's maternal grandfather, M Oudot, and dated to 1843 on the basis of its style (Fernier 1977, no. 35). Robert Fernier noted that the painting was itself the basis for the figure on the far left of Courbet's largest composition, *The Burial at Ornans* (Musée d'Orsay, Paris), of 1849. Fernier had no knowledge of the Reves drawing, which represents the artist's father, Régis Courbet, according to one of its owners, Courbet's great-nephew Paul Reverdy.

Simply on the basis of physiognomy, Reverdy's identification seems correct. Yet, when one accepts the painting and the drawing as portraits of the artist's father, issues of chronology come into question. Fernier dates another portrait of Régis Courbet to 1844 (no. 50), when the painter was twenty-five and his father was forty-six, but this date seems too late in view of the tightness of the young painter's style. More believable would be a date of 1840–1842, which would place the Reves watercolor in the late 1840s, when his father was about fifty years old.

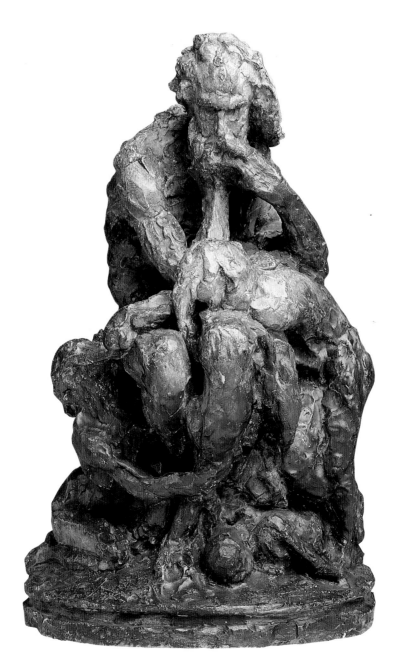

JEAN-BAPTISTE CARPEAUX

Ugolino and His Sons, cast in 1865–1875 from
an original (c. 1860)
Plaster with reddish brown stain; H. 19 in.
(48.3 cm), W. 14¾ in. (37.5 cm), D. 10⅝ in.
(27 cm)
Not signed or dated
1985.R.7

RODIN'S THE THINKER (Musée Rodin, Paris) and Jean-Baptiste Carpeaux's *Ugolino and His Sons* were the most famous French sculptures of the 19th century. The relationship between the two is direct, and there is little doubt that Rodin intended to quote Carpeaux's masterpiece when creating the central image for his unfinished work *The Gates of Hell* (final assembly 1917, Musée Rodin, Paris).

Carpeaux created *Ugolino and His Sons* in Rome, where he was working with financial assistance from the French government; he exhibited the large version in the official government Salon of 1861. By 1867, the image had become so popular that the sculptor decided to create various smaller versions, including a sublime bronze reduction, a rare early cast of which is in the collection of the Dallas Museum of Art. He also seemed fascinated with the reproduction of his clay and plaster studies for the final work. The Reves plaster is probably based on an earlier study for the full-scale Salon sculpture. In the final version, Carpeaux included three of Ugolino's sons, who seem to offer themselves to their brooding father, who, as we know from Dante, consumes them so that he can live. In the Reves plaster, only two of the sons are shown, suggesting to some scholars that this work was made in preparation for the final composition.

Unfortunately, it is impossible to conclude that the Reves plaster was among those made in Rome when Carpeaux was completing his conception of this masterpiece. It seems likely that this plaster was made in the late 1860s or early 1870s, when Carpeaux allowed many bronzes and plasters of his famous figure to be cast for the art market. The white plaster was tinted with a dull reddish brown, undoubtedly so that it would appear to be a terracotta produced in the artist's Roman studio as he finalized the composition. As an apparent study, it has the status of a "sketch," and the artist's subtlest processes of thought are caught forever in plaster.

Interestingly, Rodin owned a plaster cast of Carpeaux's *Ugolino and His Sons*. He seems to have acquired it in the late 1860s or early 1870s and used it as the basis for a group of drawings made in the 1870s. He used these in conjunction with the plaster itself as the basis for his monumental male nude, *The Thinker*.

HONORE DAUMIER

An Actor, date unknown
Pen, ink, and wash on laid paper; 9⅝ × 6⅝ in.
(24.5 × 16.8 cm)
Not signed or dated
1985.R.23

LIKE HIS CONTEMPORARIES Camille Corot and Eugène Delacroix, Honoré Daumier was obsessed with the theater. Yet, while the other two men attended the opera and the costly productions of official French houses such as the Comédie Française, Daumier preferred to study street theater and the low-cost productions of unofficial Parisian theaters. Like Charles Baudelaire and other connoisseurs of the streets, Daumier haunted the boulevards and back streets of Paris, searching for eloquent gestures, memorable profiles, and spectacular effects of light. He recorded these impressions not in sketchbooks but in his mind, and, after returning without notes to his studio, he executed his seemingly spontaneous drawings from memory. For this reason, Daumier's drawings lack the specificity and clarity of detail that one finds in the later drawings of the theater by Degas and Toulouse-Lautrec. For Daumier, the names and particular features of the actors and actresses were of little interest. Rather, he sought to entrap the essential qualities of their forms as they were filtered through his own highly selective memory.

The exaggerated pose and gestures of the figure in this powerful sheet suggest that it represents an actor, probably from the Comedia dell'Arte, which Daumier preferred throughout his life. But, the figure lacks any of the defining details of costume that would identify him as Pasquin, Harlequin, or Pierrot. The work is often referred to as a study of an actor, implying that it was made in preparation for a finished drawing or painting. But the fact that no surviving work in any medium relates directly to it clearly indicates that the sheet was made as a unified work of art rather than as part of a preparatory process.

Daumier executed most of these figure drawings with crumbly crayon or chalk rather than pen. Here, however, the precise linear incisions that define the edges and bulk of the drawing contrast perfectly with the large masses of ink that give the actor his undeniable weight and substance. This is one of the finest studies of a single figure executed by Daumier, and its excellence was recognized by K. E. Maison, the greatest connoisseur and cataloguer of Daumier's paintings and drawings. Maison owned the sheet before selling it to Emery Reves through the Swiss dealer Peter Nathan.

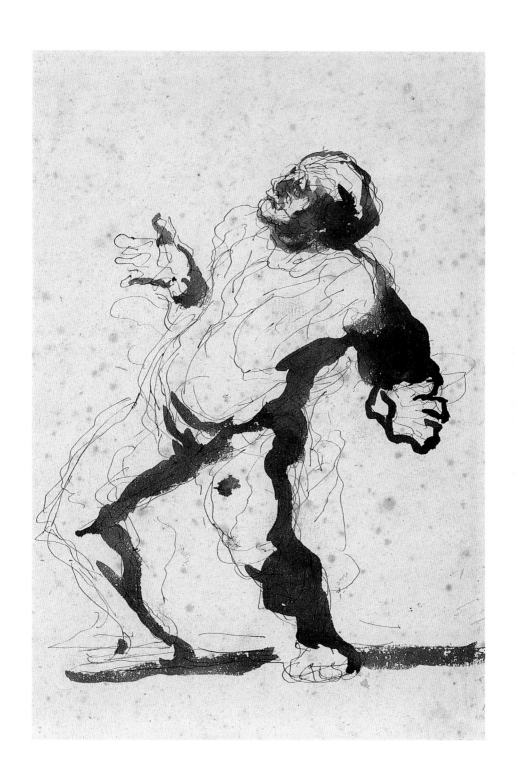

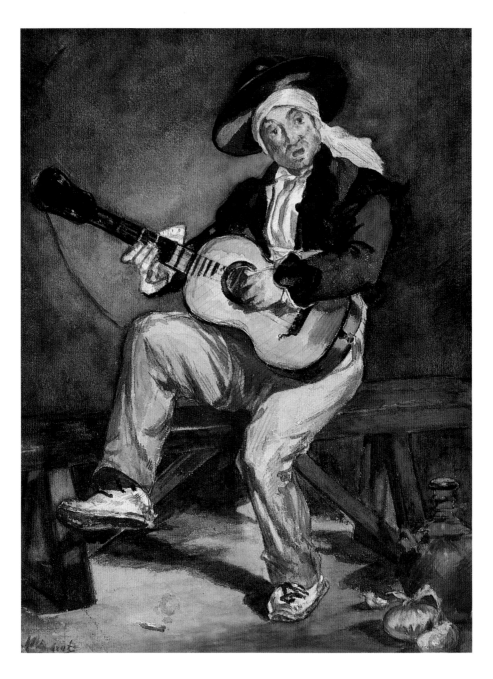

EDOUARD MANET

The Spanish Singer, 1861
Watercolor and gouache over graphite
on laid paper; 11 × 8¾ in. (28 × 22.2 cm)
Signed in brown watercolor, lower left: *Manet*
1985.R.33

THE SPANISH SINGER is among the earliest masterpieces in watercolor produced by Edouard Manet. It relates directly to a major painting of the same title, now in the Metropolitan Museum of Art in New York, which was exhibited to considerable acclaim at the Salon of 1861 under the title *Spaniard Playing the Guitar*. Unlike many earlier French painters, Manet seems not to have used a graphic preparatory process for the painting, preferring to work directly from the model and making his numerous adjustments to the composition on the painting itself. Rather than a preliminary study, this major watercolor is a reduction of the painting, probably made at the request of Manet's friend and the first owner of the work, Antonin Proust, after the success of the painting at the Salon. It may also have served Manet as he translated the painting into the graphic medium of etching. *The Spanish Singer* was etched by Manet in 1861 and was printed in five states between 1861 and 1863.

Manet's process of translation from painting to print has been extensively studied by Juliet Wilson Bareau, who notes that the drawings and prints stemming from the Metropolitan's *Spanish Singer* created a pattern of work that Manet was to use throughout much of his life (Bareau 1986). It seems that Manet started the process with a photograph of the painting, which he then traced and used as the basis for both the watercolor and the subsequent print. In the case of the Reves *Spanish Singer,* these works describe a slightly smaller pictorial field than does the painting, and certain details (the right shoe, the onions, the cigarette smoke, the shirt-front, and the scarf) have been adapted to the reduced scale of the format.

Why did Manet use watercolor? We can speculate that he wished to translate the entire work—color and all—to a small scale before translating again into the black and white medium of etching. Most of Manet's watercolors after paintings have the characteristics of miniature paintings, and collectively they tend to be quite faithful to the original except in tonality. Evidently because of the reduction in scale, Manet generally suffused the smaller versions with greater light and space, allowing them to operate independently of the paintings to which they relate. In *The Spanish Singer,* the background is both lighter and, of course, more transparent than in the oil version, and the floor recedes more dramatically.

For all its brio and life, *The Spanish Singer* has many of the oddities that mark Manet's mature style. The pose of the singer is inexplicably unstable, as if he is tapping his foot while playing and singing. His mouth is also ambiguously painted in both the oil and watercolor versions, making his status as a singer questionable. Many Manet scholars have searched in the art of Goya, Murillo, and Velásquez for sources, while others have concentrated on French influences in the painting of Greuze and Courbet. Yet, as always, Manet eludes his scholarly hunters by combining elements of many sources, heightening some and disguising others. He was also resolute in making his "Spanish" singer French. In fact, early commentators identified the singer's jacket as coming from Marseilles, and his pants must be from Montmartre!

HONORE DAUMIER
Head of Pasquin, 1862–1863
Oil on panel; 8⅞ × 6⅞ in. (22 × 16.5 cm)
Signed, upper right: *h. daumier*
1985.R.22

ALTHOUGH HE IS KNOWN chiefly for his work as a popular lithographer, Honoré Daumier was among the greatest painters of the 19th century. He painted throughout his life, and many of his works were admired by his friends and colleagues Corot, Millet, Daubigny, and the younger artists Pissarro and Cézanne. Yet, in spite of the fact that his painted oeuvre includes more than 250 works, only one major exhibition of his paintings was held during his lifetime, a showing at Durand-Ruel's gallery, mounted just months before the painter's death in 1879.

This superb small painting on panel was included in that landmark exhibition, placing it within the ranks of works that the artist himself valued enough to exhibit. It is fully signed and finished to a considerably higher degree than the majority of surviving oil paintings by Daumier. The short, gestural strokes of paint almost sculpt the head and body, giving them form in the dramatic theatrical light chosen by the artist. One is reminded of Daumier's interest in both the theater and sculpture, which he pursued unofficially, just as he painted for himself and posterity rather than for the active French art market.

The figure of Pasquin was derived from the 16th-century Italian Comedia dell'Arte. This form of popular theater plays a large role in French secular painting beginning in the late 17th century and

is associated most often with Watteau. Daumier, too, painted many characters from the Comedia dell'Arte. Many Italian and French actors in the tradition altered or expanded these characters to suit particular audiences and particular moments. A closely related painting of the same dimensions representing Paillesse or Pierrot, in a private collection in Oxford, England, may have been intended as a pair to the Reves panel.

Like most of Daumier's subjects, Comedia dell'Arte was of "low" social origins, even if many of its early audiences were aristocrats and well-to-do bourgeois. By the 19th century in France, the tradition was in decline and continued to be practiced only for a lower middle class or urban proletarian public. Thus, Daumier's Pasquin is very different from Watteau's sad Pierrot and his *galante* friends who frequented the parks, salons, and private theaters of the 18th-century French aristocracy. Whereas Watteau's characters cavort with—and satirize—their social "betters," Daumier's figures bring the world of the aristocracy back into contact with the "dangerous" urban classes from which the original characters of the Comedia dell'Arte emerged.

Daumier's Pasquin is at one with his "character." His strongly modeled upper torso and majestic head project an intense, humanist nobility. Interestingly, Daumier denied Pasquin his most

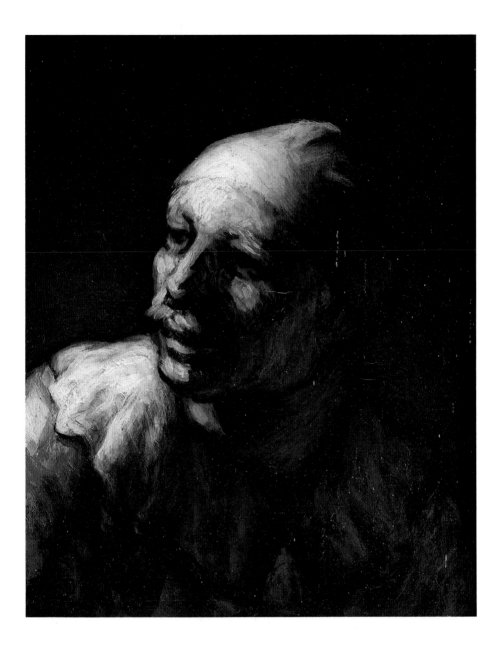

obviously expressive features, his hands,
preferring to study the seat of his intelli-
gence rather than embody his gestures.
Daumier's painting, which has been
dated to 1862–1863 (Maison 1968, vol. 1,
pl. 133), can be contrasted with the bril-
liant series of photographs of Comedia
dell'Arte figures made by his contempo-
rary the early photographer Nadar.

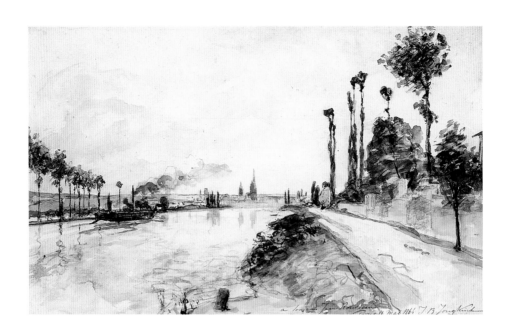

JOHAN BARTHOLD JONGKIND

Rouen, 1863 or earlier
Watercolor and charcoal on laid paper;
13 × 20¾ in. (33 × 52.7 cm)
Inscribed in ink, lower right: *a [sic] mon ami jean
Rousseau/Paris, 11 mars 1864 J. B. Jongkind*
1985.R.30

THE DUTCH PAINTER Johan Barthold Jongkind was of secondary importance as an artist, but he exerted a powerful influence on the development of impressionism and can be called one of the three or four "fathers" of the young painters who joined together as "independent" artists in 1874. Jongkind was known as a virtuoso watercolorist and landscape painter in both his native Holland and the region around Paris. This watercolor is among his most accomplished and mature. If its inscription was made at the same moment as the drawing itself, it dates from the spring of 1864. It is more likely the watercolor was retrieved from a sketchbook or from a large stack of watercolors already completed by the artist and inscribed to its recipient. The watercolor seems to have been made in the summer months, when the foliage was fully developed, and, hence, can plausibly be dated to the previous summer.

For his motif, Jongkind chose a spot on the towing path along the Seine River just north of Rouen. The principal inland port in France, Rouen was also a medieval ecclesiastical capital of great importance, and the spires of its famous cathedral rise from the alluvial plain of the Seine at the center of Jongkind's landscape. Yet, despite the centrality of the spires, they are overwhelmed in scale and pictorial importance by the foreground and middle-ground trees and by the *péniche à vapeur,* or motorized barge, that plies the river, steaming to the port of Le Havre. For Jongkind, painting was an easy, direct, and apparently unfettered act of transcription, in which modernity was more important than history. The sheer simplicity and directness of his paintings in watercolor and oil gave strength to the young impressionists who sought to bring their world firmly forward and anchor it in representation.

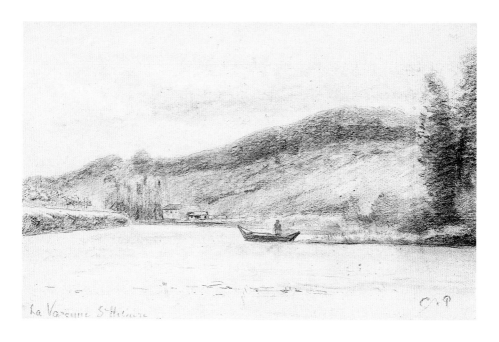

CAMILLE PISSARRO

The Marne River at Varenne-Saint-Hilaire, 1863–1865
Charcoal on wove paper; 12 × 18½ in. (30.5 × 46.9 cm)
Inscribed, lower left: *La Varenne St. Hilaire;*
studio stamp, lower right: *C. P.*
1985.R.51

ALTHOUGH CAMILLE PISSARRO was already in his mid-thirties when he made this large compositional drawing, his career was just beginning to take form. His submissions to the Salon of 1863 had been rejected; in 1865, when Manet exhibited his *Olympia* (Musée d'Orsay, Paris) and *The Mocking of Christ* (Art Institute of Chicago) at the Salon, Pissarro had two works accepted by the jury. Only one of these, *The Banks of the Marne at Chennevierres* (National Gallery of Scotland, Edinburgh) survived the sacking of his studio by German troops in 1871. The second, called simply *The Banks of the Water,* must have been similar to the Edinburgh painting, and from the evidence of the style and inscription, we can conclude that this drawing is a compositional study for one or the other of those paintings.

Pissarro and his growing family lived in the village of Varenne-Saint-Hilaire (or Varenne-sur-Maur) throughout much of the years 1863–1865. Because his family did not approve of his relationship with his common-law wife, Julie Vellay, Pissarro was forced to keep his wife and children away from Paris and to support them on his meager sales. His first real critical success as a painter came in 1865,

but his sales that year were poor, and the family lived from hand to mouth.

This masterly sheet is a study of tones and values in the landscape. In making it, Pissarro laid in the masses of the landscape and created a simple rhythm of vertical, horizontal, and undulating lines. The river composition and horizontal format of the drawing relate it to the Salon paintings of the great landscape painter Charles-François Daubigny. Pissarro's sheet, however, is free from the slightly fussy details that often mar Daubigny's compositions. In making a few clear decisions and creating a composition without undue incident, Pissarro had begun to approach the landscape aesthetic that came to be so admired by Emile Zola, who called Pissarro's great landscape of 1866, *The Banks of the Marne in Winter* (Art Institute of Chicago), "grave and reasoned" (Zola 1866). Fortunately, a small group of Pissarro's drawings from the mid-1860s survive, giving us a sense of what the missing paintings must have looked like. The Reves sheet is among the most ambitious of these, and can be compared with drawings at the Ashmolean Museum, the Yale University Art Gallery, and the Museum of Fine Arts, Boston.

PIERRE-AUGUSTE RENOIR
Lise Sewing, 1866–1868
Oil on canvas; 22 × 18 in. (55.9 × 45.7 cm)
Signed, lower left: *A. Renoir*
1985.R.59

PIERRE-AUGUSTE RENOIR met Lise Tréhot in the spring of 1866, when he painted in and around the Forest of Fontainebleau with Jules Le Coeur and Alfred Sisley. Between that year and early 1872, he painted her obsessively, which has led most scholars to conclude that they were lovers. In 1872, Tréhot abandoned Renoir and married a young architect, Georges Brière de l'Isle. Tradition holds that she never again saw Renoir.

Of the two portraits of Tréhot in the Reves Collection, *Lise Sewing* is the earlier. Douglas Cooper, who studied both portraits and all the surviving family documents, concluded from literary and stylistic evidence that the painting, along with another (Barnes Collection, Merion, Pennsylvania), was done in 1866, shortly after Renoir met Tréhot (Cooper 1959). Although Cooper's arguments are justified, they are not utterly convincing, and the painting can be more closely compared on stylistic grounds to a work signed and dated 1868 at the National-galerie, Berlin, entitled *Lise,* or *The Gypsy Girl.*

Lise Sewing is not in any strict sense a portrait. Rather, Renoir used Tréhot as a model for a conventional painting of a woman sewing. His allusions to current fashion link this representation with the contemporary paintings of Manet, while the broad treatment of the background and sparing use of the palette knife have often evoked comparison with Courbet's paintings of the mid-1860s. This comparison is compelling; Renoir, like Courbet, was a painter of flesh and blood, not of fashion or appearance, and the fact that the subject is portrayed as self-occupied and married gives the male viewer for whom it might have been made an even greater pleasure in admiring the beauty of this moral and, hence, inaccessible woman.

Perhaps the most fascinating aspect of this superb painting is its provenance; it was owned by the sitter throughout her life.

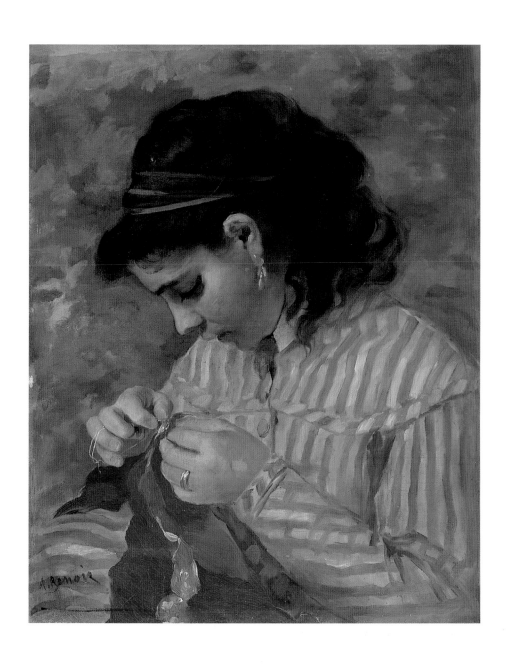

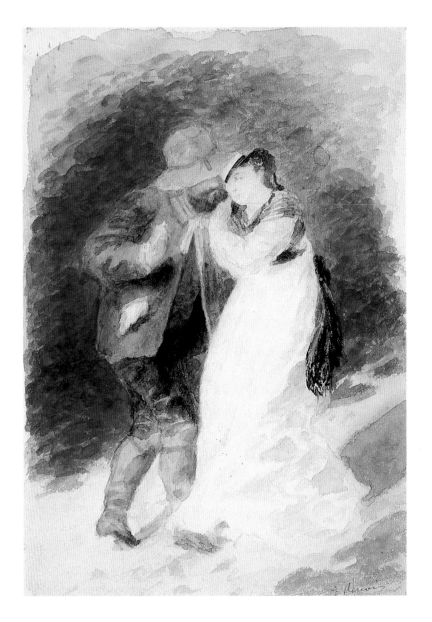

PIERRE-AUGUSTE RENOIR
M Jules Le Coeur and Mlle Clémence Tréhot, 1867
Watercolor on wove paper; 10 × 6⅞ in.
(25.5 × 17.5 cm)
Signed, lower right: *A Renoir*
1985.R.61

WATERCOLOR IS A thoroughly British medium, and although many great French artists adapted it for their use, the history of watercolor in France is largely confined to the second half of the 19th century. It was not until 1878 that the French Watercolor Society was formed. Pierre-Auguste Renoir used the medium throughout his working life. Having been trained as a porcelain painter, he would have found the medium good preparation for work with transparent glazes.

This watercolor has been convincingly dated to 1866–1867 and, thus, is from the first important decade in

Renoir's working life. Because it is signed, the work was likely made with either exhibition or sale in mind, perhaps even as a souvenir of a tender moment in the garden.

Like many of the Reves Renoirs, this one led Emery Reves and his friend the scholar-connoisseur Douglas Cooper along a delightful path in their efforts to identify the subjects. Combining circumstantial information from the original owner and archival research, Cooper was able to identify the man as Renoir's friend the painter Jules Le Coeur, with whom the future impressionist maintained a close relationship between 1865 and 1870. Le Coeur and Renoir met while painting in the Forest of Fontainebleau (Renoir included Le Coeur in a painting of 1866, *Jules Le Coeur in the Forest of Fontainebleau,* Museu de Arte, São Paulo), and it is likely that this watercolor was painted in a garden near the village of Marlotte, where both painters were staying. Le Coeur was already widowed in 1866–1867 and had established a close friendship with a young woman from the area, Clémence Tréhot, whom Reves and Cooper identified as the woman represented here. Yet, this identification is possibly incorrect. Renoir had established an intimate relationship with Clémence's sister Lise, who was his favorite model of the time. He had depicted her in an identical costume in three other paintings of 1867 (Daulte 1959b, 29, 31, 33), and there is no evidence that Clémence ever served as a model.

What seems at first to be a charmed, innocent encounter in a garden becomes, on closer inspection, an oddly ambiguous scene. Le Coeur is dressed in rough country garb and moves aggressively toward "Clémence." She seems to resist

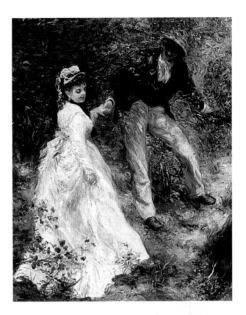

Pierre-Auguste Renoir, *La Promenade,* 1870. Oil on canvas, 32 × 25½ in. (81.3 × 65 cm). J. Paul Getty Museum, Malibu, California.

his advance, her hand raised to push his face away. The dark blue background does little to lessen the effect of an unwanted or overly insistent advance. The easy, sun-dappled effect gives way to a reading that is utterly unlike the familiar scenes of lighthearted *fêtes galantes.* What did Renoir mean by this watercolor? Did he intend to "illustrate" a passage from Emile Zola's 1867 novel *Thérèse Raquin?* Or was he simply recording a scene in a garden? If we were meant to know the identity of the models, as we do today, does the scene record Renoir's jealousy of Le Coeur? Or, more probably, were these friends of Renoir used simply as models in his delicate attempt to study in watercolor the tensions in male-female relationships? Renoir's composition raises more questions than it answers.

The watercolor acted as an informal prototype for Renoir's 1870 painting of a similar subject, *La Promenade* (see fig.).

HENRI FANTIN-LATOUR
Portrait of Edouard Manet, 1867
Pen and ink on wove paper; 5⅛ × 5⅛ in.
(13 × 13 cm)
Signed, lower left: *Fantin-*
1985.R.27

THIS MARVELOUS PORTRAIT relates to Henri Fantin-Latour's great three-quarter-length portrait of Edouard Manet now in the Art Institute of Chicago. Accepted by the Salon of 1867, the portrait was a rallying cry for modern painting at a Salon in which Manet's own submissions had been rejected. Hence, Manet was "present" in the Salon, although his paintings were not. Later in the year, Manet exhibited a large number of his most important works in a private building outside the Universal Exposition, thereby recalling the legendary private exhibition of Courbet's works outside the Universal Exposition of 1855. Like Courbet, Manet chose to present himself to the world as an outsider and an artist in control of his destiny, rather than as an artist whose work was made to be judged by the French state.

The Reves drawing has never been published and, thus, has an uncertain relationship to the various events of 1867 to which it relates. Was it made before the Universal Exposition, perhaps as an illustration for the pamphlet on Manet prepared by the young Emile Zola? If so, it was never used. Because its early provenance is not known, its function cannot be specified. All that can be said with certainty is that the square-format drawing in pen and ink was made after the painting, in a technique that easily lends itself to reproduction.

The drawing represents Manet as a respectable bourgeois citizen rather than a painter, and might have been intended to defuse the idea that Manet was a social as well as artistic radical. Perhaps the wittiest aspect of this distinguished small work is its forceful signature. Fantin-Latour signed his name boldly, including the hyphen after "Fantin," but, as was usual with him, omitting "Latour." Here, by placing his signature and the hyphen to the left of Manet's image, Fantin-Latour suggests that Manet is "la tour," the tower of modern art.

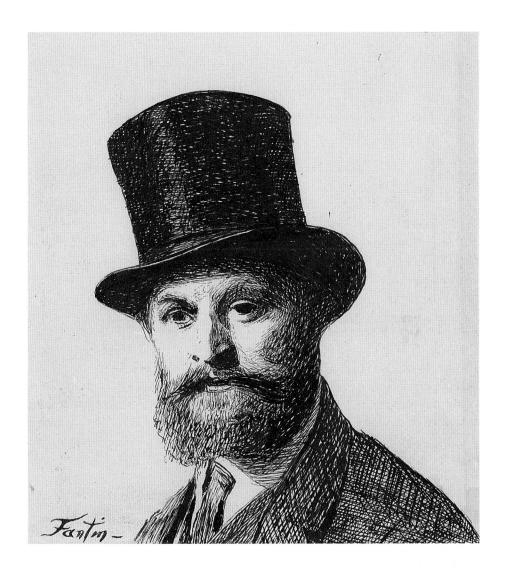

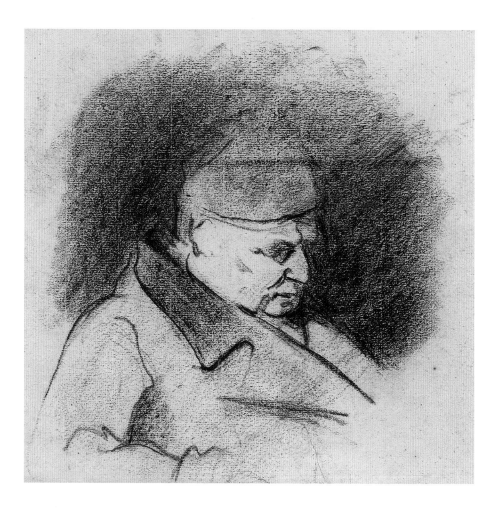

PAUL CEZANNE

Portrait of the Artist's Father, 1868–1873
Charcoal on laid paper; 9⅛ × 10¹⁄₁₆ in.
(23.2 × 24.5 cm)
Not signed or dated
1985.R.13

PAUL CEZANNE WAS an assiduous drafts-man whose drawings play a critical role in the development of his painting. In fact, Cézanne's simultaneous concern with line and color in painting must be seen as an attempt to reunite the two seemingly opposing strands of French 19th-century art: a devotion to line and a concern with the expressive and emotional character of color. Like many important modern artists, Cézanne consumed sketchbooks; he took them with him on walks in the country and on trips to the Louvre, and drew obsessively after dinner or at other quiet moments at home.

This sheet represents the artist's dominating and authoritarian father, Louis-Auguste Cézanne. A successful banker, the elder Cézanne was among the most substantial citizens of Aix-en-Provence. He assisted his son financially in his lifetime and provided for him generously in his will. Yet, he rarely approved of his son's decisions, either professional or personal. In spite of a strained relationship, Cézanne spent a good deal of time with his father. Preferring to live at home during times of crisis, the artist produced many portraits of his father, both painted and drawn.

The Reves portrait is among the stronger drawings. It seems to have been made at home in Aix-en-Provence, most likely in the evening, when the family remained together reading and chatting after dinner. Louis-Auguste is shown reading or studying, completely oblivious to the act of representation. This is an intimate, "occasional" portrait rather than a formal likeness, suggesting that Cézanne used his father simply as a convenient model, not as the object of formal or psychological study. The drawing has been conventionally dated to the late 1870s and related to a small group of pencil portraits of Cézanne's father that probably date from that period. However, Cézanne rarely used the medium of charcoal in the late 1870s, and the style of the sheet is closer to the tonal studies of the late 1860s and early 1870s than it is to the analytical pencil drawings made late in the decade.

The great Cézanne scholar John Rewald found a fascinating passage in Louis Vauxcelles's obituary of Cézanne published in *Gil Blas,* 25 October 1906: "I saw last year when visiting Cézanne's son a drawing in charcoal . . . representing the painter's father as a bourgeois type from Provence" (Rewald 1978). Rewald felt that the Reves sheet was the only surviving one that fits the description, and if so, Cézanne gave this wonderfully intimate study of his father to his own son.

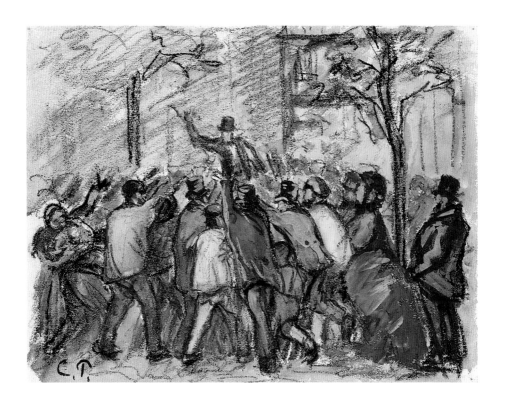

CAMILLE PISSARRO
Urban Uprising in Paris, 1870
Charcoal, wash, and gouache on wove paper;
7⅝ × 10 in. (19.4 × 25.4 cm)
Initialed in brown ink, lower left: *C. P.*
1985.R.49

CAMILLE PISSARRO WAS the most politically involved artist among the impressionists. His political consciousness was activated by being an outsider—both Jewish and Danish—in France during his youth and by the examples of Gustave Courbet and his friend the radical philosopher Pierre-Joseph Proudhon. Pissarro read Proudhon's book about art and politics, *On the Theory of Art and Its Social Purpose* (1865), and warmed not only to the philosopher's distrust of authoritarian government but also to his belief that artists had a responsibility to engage with the social world. A lifelong anarchist, Pissarro constantly thought about

the role of the artist and his "work" in the increasingly industrialized world. By painting both urban and agrarian life, he attempted to produce a balanced pictorial world that could set an example for a balanced social world.

This powerful drawing representing an urban uprising is unique in Pissarro's career. It has traditionally been entitled *Anarchist Meeting on the Boulevards,* but this is surely too precise, given the fact that we know almost nothing about the drawing. That it represents an urban uprising is clear. A central figure of a man gestures with his raised arm as a crowd of men and women gather around him. Pissarro was careful to depict the crowd

in motion, which lends an ominous and unstable quality to the subject. The drawing has none of the balanced and static character of Jacques-Louis David's famous *Oath of the Tennis Court* (1791, Musée du Louvre, on loan to the Musée National du Château, Versailles), nor does it have the careful observation of figural types that one sees in Louis-Léopold Boilly's street scenes. Rather, its art historical origins lie squarely in the art of Honoré Daumier, whose caricatures and politics Pissarro admired intensely.

To decode the subject of the drawing, it is necessary to place it in time, and this proves to be a maddeningly complex task. It has distinct stylistic parallels to drawings done by Pissarro as early as 1854–1855 in Caracas, Venezuela, but a generalized treatment of urban figures persisted in Pissarro's graphic oeuvre through the 1890s. The highly organized, symmetrical composition leads one to date it to the 1850s or 1860s, but Pissarro drew no comparable scenes in those years, turning to the subject of urban politics in his graphic art only in 1890. Thus the conundrum—early style, late subject.

What precisely is the subject? Pissarro was careful to delineate the sex and social class of the figures while avoiding their individuality. Since there is a spectrum from urban workers to well-dressed figures of both sexes, the gathering does not represent antibourgeois workers or politicized students. Yet, the drawing does retain the sense of collective action. Pissarro was an active participant in Parisian culture throughout the 1860s and could easily have witnessed such a scene,

had one occurred. However, the virtual police state of the Second Empire (1852–1870) ensured that such gatherings were rapidly dispersed, and not even the highly politicized Daumier represented an urban uprising in the 1860s. Pissarro probably saw scenes like this one at the onset of the Franco-Prussian War in 1870, before his departure from France to England. Unfortunately for the history of art, Pissarro was living in exile during the short-lived Commune of 1871, whose Republican political aims were close to his own.

Given its mixture of the sexes and social classes, the drawing most likely represents a group of anti-Prussian Parisians before Prussia invaded France. It is known that Pissarro was roused by a patriotic fervor at that moment and that he even tried, unsuccessfully, to enlist in the French army in 1870. Surely it was this patriotism that he recorded on this powerful sheet.

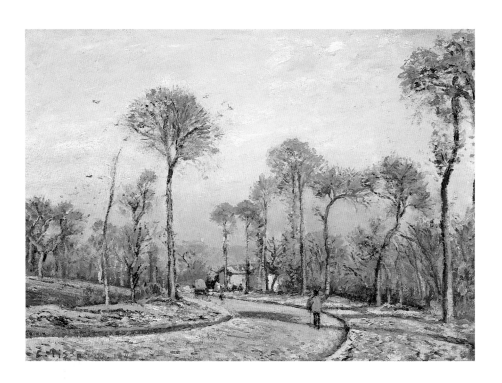

CAMILLE PISSARRO

The Road to Versailles, Louveciennes: Morning Frost, 1871
Oil on canvas; 12⅞ × 18⅛ in. (33 × 46 cm)
Signed and dated, lower left: *C. Pissarro 1871*
1985.R.42

PISSARRO WAS AT the height of his powers in 1871, when he painted this compact and subtle study of morning light playing on a street near his home in Louveciennes. Unable to enlist in the French army during the Franco-Prussian War because of his Danish citizenship, Pissarro fled France at the end of 1870 and remained in exile in London until July 1871. When he returned to France, he found that his house had been ransacked by the German army and that many of his early paintings had been destroyed. Rather than being dissuaded by this setback, Pissarro commenced a campaign of landscapes representing Louveciennes that are among the greatest of his career. All the pictures benefit greatly from his time in England, not only because he was able to paint with fellow exiles Monet, Sisley, and Daubigny during that year but also because he had studied the paintings, oil sketches, and watercolors by Constable and Turner in public collections in London. This injection of pictorial energy from earlier in the century was all that Pissarro needed to solidify his position as one of the most prominent landscape painters of the century. Whether large or small, his paintings summarize more than a decade of study, both from nature and from the greatest painters of nature.

This small canvas was painted late in 1871 in a successful attempt to trap in paint one of nature's most elusive moods during autumn and winter. On clear, cold nights, the dew that gathers on the dead leaves and grasses freezes, and in the light of dawn, the entire landscape is cloaked in a white crystalline covering that disappears as soon as it is warmed by the sun. This effect—in French, *gelée blanche,* in English, "hoarfrost," or more poetically, "morning frost"—was a particular favorite of Pissarro, who preferred it to painting snow effects. The challenges in representing it are enormous because the frost melts so quickly in the sun. For this reason, Pissarro prepared a small canvas, working on it only during clear late-fall or early-winter mornings and waiting for the morning frost, so that, with whitened mixtures of his colors, he could lay a frosting of white paint on the roughened surface of a painting that was essentially finished.

All of the old labels on the painting identify its site as Poissy, a hillside town further west of Paris than Louveciennes. Pissarro is not known to have visited Poissy, and his son Ludovic-Rodo identified the site as Louveciennes, where Pissarro lived throughout the winter of 1871–1872, and where he produced all the other paintings that survive from that winter (Pissarro 1989, vol. 2, no. 127). For that reason, we conclude that the painting was made in Louveciennes, as catalogued.

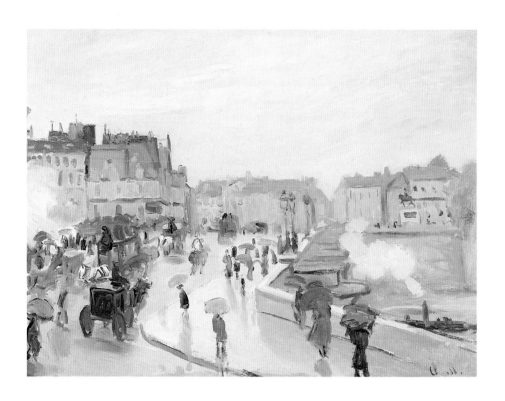

CLAUDE MONET
The Pont Neuf, 1871
Oil on canvas; 20¹⁵⁄₁₆ × 28½ in. (53.1 × 72.4 cm)
Signed, lower right: *Cl. M.*
1985.R.38

CLAUDE MONET RETURNED to Paris in the fall of 1871 after more than a year of exile in England and Holland. He found a city ravaged from without by the Franco-Prussian War and from within by the Commune. Although his sympathies were with the Communards in the latter struggle, he arrived after they had been violently suppressed by the national government, and he found a city in deep despair. He painted only one work during that time, *The Pont Neuf,* and it can be contrasted in every way with the series of Parisian cityscapes that he made in 1866 and 1867, before the debacles that so wounded the French capital. Where the earlier paintings were made from the balconies and windows of the Louvre, looking out on a city alive with movement and color on sunny summer days, the Reves painting is essentially a grisaille study of inclement weather, probably painted from a rented room or the apartment of a friend. Gone are the monuments of Paris—the dome of the Panthéon or the Church of Saint-Germain-l'Auxerrois—that center his earlier paintings. Instead, we see the Pont Neuf covered with carriages and pedestrians. The small houses of the famous place Dauphine are scarcely more important than the anonymous apartments across the river. Monet's intent is even clearer when we compare his work with Renoir's painting of the same bridge (see fig.). For Renoir, all

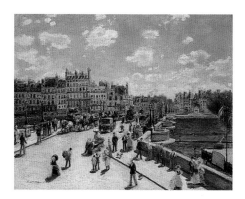

Pierre-Auguste Renoir, *Pont Neuf, Paris*, 1872. Oil
on canvas, 29⅝ × 36⅞ in. (75.3 × 93.7 cm). National
Gallery of Art, Washington, D.C., Ailsa Mellon Bruce
Collection.

sparkles in the sun; shadows give form to
the figures as they bustle over the bridge.

The chief feature of Monet's painting
is its featurelessness. The 19th-century
equestrian statue of Henri IV, a model
monarch for non-Royalist liberals such
as Monet, is reduced almost to a toy in
this painting. In reality, the sculpture is
considerably nearer, and hence larger,
than it appears here. In addition, Monet
depicts the sky as a series of streaks of
warm gray paint, evoking those fall days
in Paris when the sky is deadened by
a high blanket of characterless clouds.
The wet pavement reflects the carriages
and figures, who seem almost to glide
along the surface.

We can easily read this canvas as
an embodiment in paint of the cultural
grief felt by the French after the recent
travails in their history. In this reading,
the weather is depressing, and the motif
one of human—specifically Parisian—
continuity in the face of change. Neither
rain nor history can deter the relentless
movement of the great city. To pursue
this reading further, even the name of

the painting's principal motif takes on
a double irony: the Pont Neuf, or New
Bridge, is in reality the oldest. In this
painting about "passage," monarchs,
rulers, and governments come and go,
but the city continues.

Yet, this reading is dependent on
the date of the picture, and that is pre-
cisely what Monet withholds from us.
He elected to initial the painting, in
a manner that he used for his fully re-
solved oil studies, but did not date it,
as he would have had he "finished" the
painting. If we did not know the date but
were forced to guess it, we could easily
put it a little later in his career, and thus
disconnect it from this painful moment
in the history of France. The painting
could then be explained as a kind of
Whistlerian exercise in monochrome
or grisaille painting, and as a tour de
force of brushwork held in check by its
simple palette. Indeed, the painting can
be read as a symphony in gray. We must
remember that Monet had worked most
recently in London and that the example
of Whistler's oeuvre was therefore fresh
in his mind.

This painting, among all of Monet's
cityscapes of the 1860s and 1870s, boldly
points forward to the Parisian canvases of
Albert Marquet that were so popular in
Paris at the end of Monet's life and that
had such a powerful effect on the urban
vision of America's most important real-
ist painter, Edward Hopper.

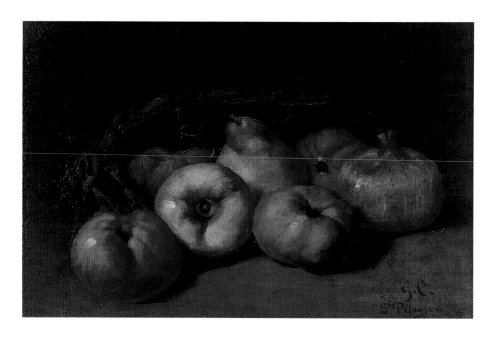

GUSTAVE COURBET
Still Life with Apples, Pear, and Pomegranates, 1871–1872
Oil on canvas; 10¾ × 16¼ in. (27.3 × 41.3 cm)
Initialed and inscribed, lower right: *G. C. Ste Pélagie*
1985.R.18

GUSTAVE COURBET WAS arrested in June 1871 and transferred to the national prison at Sainte-Pélagie in September 1872 for his role in the toppling of the Vendôme Column during the Commune the year before. He occupied cell four at Sainte-Pélagie, where he had visited his friend the political philosopher Proudhon twenty years earlier. As always, the artist was proud and defiant and, perhaps as a result, was treated as a common, rather than political, prisoner. His stay in prison was cut short by ill health, and on 6 January 1872 he was transferred to a private clinic in Neuilly as a ward of the state. He stayed there throughout the remainder of his sentence.

Courbet was not the first famous French artist who had been in prison, and when he painted the small group of still lifes inscribed with the name of the prison, he worked in a tradition of political artists who defy the state. Needless to say, his work done in prison could not be in any way overtly political; he was forbidden models and was thus forced to work from the fruits and flowers his sister managed to bring into Sainte-Pélagie. Yet, the mere fact that he painted was an act of independence and personal authority. "I can still paint," he tells us through these works. "The state cannot suppress my painting."

The Reves *Still Life with Apples, Pear, and Pomegranates* is one of fifteen surviving paintings bearing the inscription "Ste Pélagie." The others are scattered in museums and private collections in England, the United States, Scotland, France, Germany, Holland, Switzerland, and Denmark. These might well have encircled the great self-portrait at Sainte-

Pélagie (1871, Musée Courbet, Ornans). When grouped in his cell, they would have conveyed a character of peasant earthiness in the repressive gloom of the prison. Evidence suggests that many of the inscriptions were added at a later date, perhaps to communicate to the viewer a clear idea of Courbet's political views and of his willingness to suffer for them.

Few still lifes in the history of French art convey the voluptuousness and physicality of fruit as well as Courbet's do. Perhaps only Chardin's plums come close. But the most fascinating parallels with Courbet's fruits can be found in French still-life photography of the 1850s and 1860s, particularly in the dusky still lifes of Henri le Secq. There are also affinities between the Sainte-Pélagie still lifes of Courbet and the still lifes of the early 1870s that Paul Cézanne made while he was living and working in the environs of Paris. Unfortunately, it is virtually impossible to find any direct link between the painters at that time. Because of his controversial political views, Courbet's paintings were not publicly exhibited in the early 1870s, and only one of the Sainte-Pélagie still lifes has an early provenance that can be linked with the impressionists. This work, *Potatoes and Scallops* (1871, private collection, Tokyo), was owned by Henri Rouart, who collected impressionist works but was not in the same circle as Cézanne. Pissarro's 1874 portrait of Cézanne (private collection, London) includes a caricature of Courbet in the background, and many writers have linked their careers. However, there is simply no evidence that they ever met.

Fortunately, Emery Reves recognized the connection and bought a small still life by each artist, both made in the 1870s.

The Reves *Still Life* is catalogued by Fernier but is erroneously placed in the collection of the Norton Gallery and School of Art in West Palm Beach, Florida (Fernier 1977, no. 761). Paul Rosenberg, from whom Emery Reves bought the painting in 1967, indicated that he had acquired it from a dealer in Zurich, who said that it originated in a Parisian private collection. No more precise information about the early history of this fascinating painting has been found.

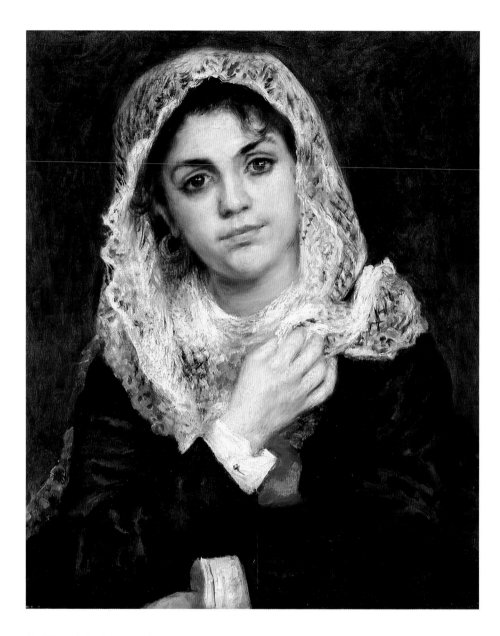

PIERRE-AUGUSTE RENOIR
Lise in a White Shawl, 1871–1872
Oil on canvas; 22 × 18 in. (55.9 × 45.7 cm)
Not signed or dated
1985.R.58

EMERY REVES and Douglas Cooper each considered this superb—and sentimental —portrait of Lise Tréhot to be the last of many paintings that Renoir made of his favorite model. Cooper even hints that the painting may have been made as a wedding present for Tréhot, who married Georges Brière de l'Isle in Paris on 24 April 1872. The white scarf she wears over her head lends the representation an air of modesty, and her gesture focuses our attention on her face, with its large, dark eyes, rather than on her body. This character of modesty lends credence to Cooper's idea that the picture was a wedding gift.

Renoir used Tréhot as a model for a full-length portrait painted in 1871–1872 (Guggenheim Museum, New York). Called *Girl Feeding a Bird (Lise)*, this work was made as part of an elaborate pictorial dialogue with Manet and Courbet. In it, Tréhot wears the same dress and earrings as she does in the Reves portrait, which suggests that the two works were painted at the same time, and that Renoir retained the more ambi-tious picture for exhibition and sale and gave the smaller, more intimate picture to his favorite model, who kept it throughout her life.

All evidence suggests that Tréhot was closely connected to Renoir, but that she struggled after her marriage to assure her bourgeois respectability by cutting off all connections with the painter. This, the last of Renoir's pictorial "homages" to Tréhot, is a work of utter frankness and simplicity. How they must have stared into each other's eyes as Renoir painted her this last time. His brush lingered over her shawl, exploring its patterns and folds, but his most confident strokes define her features. Her lips, gently closed, are highlighted with tiny touches of white paint that make them look moist. The dimple beneath her mouth appears almost to tremble, and her eyes seem filled with tears. If ever there was a subtler and more satisfying representation of regret and loss, it is difficult to bring to mind. One almost wishes that Renoir himself had kept this painting.

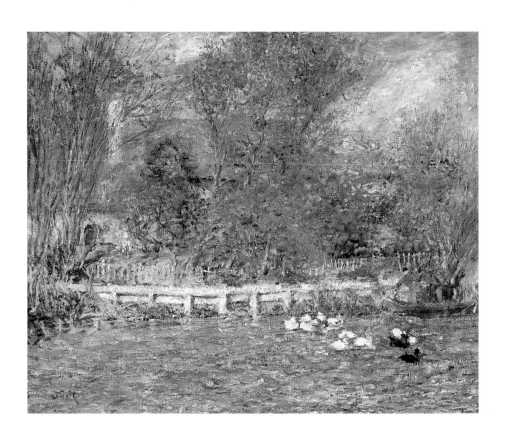

PIERRE-AUGUSTE RENOIR

The Duck Pond, 1873
Oil on canvas; 19¾ × 24 in. (50.2 × 61 cm)
Signed, lower left: *renoir*
1985.R.56

RENOIR AND MONET began portraying the same landscape in 1869, when they simultaneously painted at the famous waterside cafe La Grenouillère (The Frogpond) at Bougival. This collaboration has often been analyzed and used to point out the real aesthetic differences between the two artists—Monet, the painter of light and water, and Renoir, the painter of the human form.

The two artists painted together on many subsequent occasions. In 1873, they made a single excursion during which Renoir painted two landscapes and Monet completed one. The Reves *Duck Pond* is one of this trio of paintings; Renoir's second also resides in Dallas, in a private collection. Monet's single canvas remains in a Parisian private collection. The Reves Renoir and the Monet have often been compared in print, most powerfully by John Rewald, the preeminent historian of impressionism and the author of the standard history of the movement. When shown side by side on a printed page, the two works appear startlingly similar, each artist having succumbed to a desire to show nature in all its visual complexity. The tree branches seem to move in the breeze, and the surface of the pond trembles in an agitated fashion. Both pictures have a restiveness that many early critics of impressionism found at once ugly and resolutely modern. In their view, the nervousness of the paintings was an analogue for the ills of contemporary urban society.

Interestingly, no student of landscape imagery has located the motif painted by Renoir and Monet, which is most likely in the region of Argenteuil, where Monet lived and where both painters worked in the summers of 1873 and 1874. Fortunately, Monet dated his painting, allowing us to position all works in the first of these two collaborative summers. Their friend Camille Pissarro must have seen these works, because he began his own variants of the composition in the summer of 1874, when he painted a series representing a duck pond in rural Brittany. All three artists relished the picturesque activity of such farm-pond scenes and painted them as an alternative to their more famous representations of bourgeois flower gardens and leisure boating.

CAMILLE PISSARRO

The Rue de l'Hermitage, Pontoise, 1873–1875
Pencil, watercolor, and gouache on wove paper;
7⅛ × 9⁹⁄₁₆ in. (17.9 × 24.2 cm)
Initialed, lower right: *C P;* studio stamp, lower
right: *C. P.*
1985.R.45

THIS PREVIOUSLY UNPUBLISHED water-color is unique in Pissarro's career, as it is the only watercolor depicting the rue de l'Hermitage, on which Pissarro lived with his family throughout much of the 1870s. Pissarro painted the street seven times, and one pencil drawing also survives. Neither the drawing nor the watercolor relates in any direct way to a painting, clearly indicating that for Pissarro in the early and mid-1870s each work of art was made independently, rather than in the traditional hierarchy of drawing, watercolor, oil sketch, and "finished" painting.

Stylistic evidence suggests that this watercolor was made in the early or mid-1870s, when Pissarro concentrated on street scenes with balanced architectural masses. The interplay of red, green, and blue and the contrast of large areas of white and dark give the work a visual

strength that belies its small size. It was made in a medium that Pissarro used throughout his life but that, curiously, was without a particularly distinguished history in French art. Watercolor is considered today, as it was in the 19th century, a quintessentially English medium, whose greatest single adherent was Turner. Pissarro had been able to study English watercolors on several occasions by 1873–1875, when he made this study of the rue de l'Hermitage. When we look at this masterful watercolor and think about the importance of the medium to Pissarro's great pupil and colleague Paul Cézanne, with whom he was working when he completed this sheet, it is easier to give back to the medium its French history.

The pencil initials at the lower right indicate that Pissarro himself considered this sheet to be "finished."

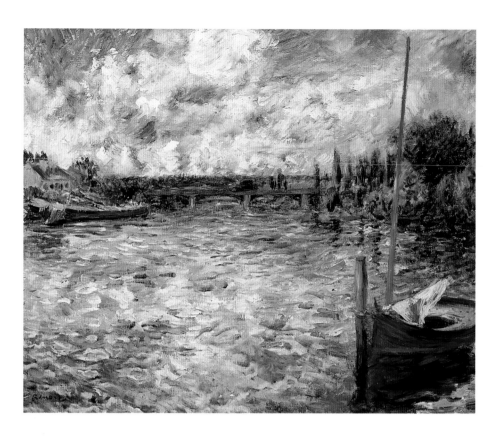

PIERRE-AUGUSTE RENOIR

The Seine at Châtou, c. 1874
Oil on canvas; 20 × 25 in. (50.8 × 63.5 cm)
Signed, lower left: *Renoir*
1985.R.62

THE SEINE AT CHATOU is among the finest, boldest, and best preserved of Renoir's landscapes from the first half of the 1870s. Although Renoir is known to have worked in Argenteuil with Monet during the summers of 1873 and 1874, when this work was painted, writers have used the railroad bridge to identify its site as the nearby village of Châtou, where Renoir painted frequently throughout the 1870s and early 1880s.

When one compares this work to the most technically and compositionally advanced paintings by Monet, Sisley, or Pissarro from the same years, Renoir's landscape becomes even bolder. Virtually its entire surface is devoted to "unstable" elements, either water or sky, and as if this visual instability were not enough, Renoir refused the viewer even a strip of path or slip of river bank on which to stand. As a result, we become disembodied, floating viewers whose eyes are forced to wander across the water, looking for admission to this otherwise pleasant summer scene. This sense of distancing and instability is strengthened by Renoir's omission of all human figures from his landscape.

Perhaps because Renoir was known even to his friends and contemporaries as a figure painter, he allowed himself free rein when he painted landscapes. They therefore have a force and originality of conception that place them on the level of Delacroix's landscapes of a generation earlier. This modest but important example was acquired from the painter by the greatest dealer of impressionist painting, Paul Durand-Ruel, in 1891 and sold to an amateur collector in Le Havre in 1900. Renoir himself was shy about his landscapes and refused to exhibit any in the impressionist exhibitions of 1874 and 1876. He relented only in 1877, when he showed five landscapes. This painting evidently was never exhibited in the 19th century and, perhaps for that reason, is not as well known as it deserves to be.

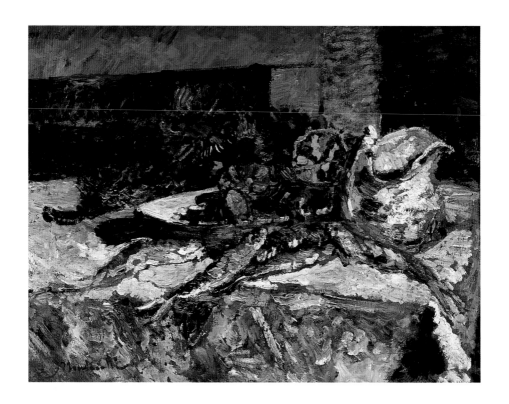

ADOLPHE MONTICELLI
Still Life with Sardines and Sea Urchins, 1875
or 1880–1882
Oil on wood panel; 18 × 23⅝ in. (45.7 × 60 cm)
Signed, lower left: *Monticelli*
1985.R.39

NO ARTIST FROM the south of France had a more profound effect on the art of Vincent van Gogh than did Adolphe Monticelli. Van Gogh's correspondence is filled with admiring references to the great painter of Marseilles, whose wildly colorful and painterly works of art the young Dutchman used as an exemplar of "southern" painting. Van Gogh's admiration of Monticelli's work was shared by many late 19th- and early 20th-century collectors, and because the demand exceeded the supply, a good many works attributed to Monticelli in collections throughout the world are known forgeries.

Surely not a forgery, the Reves panel is one of only seventeen known still-life paintings by the prolific artist. It was among twenty-six major paintings by Monticelli from the famous collection of the Marseilles businessman François Honnorat. Honnorat loaned it to many early exhibitions, and it appeared in the most important Monticelli exhibition, which was held in 1908 at the Salon d'Automne in Paris.

When looking at this sensuous still life, one can see just why van Gogh re-spected Monticelli. Rather than choose polite or refined forms like those preferred by most still-life painters, Monticelli went to the Marseilles fish market and purchased fresh sardines and a basket of spiny sea urchins. He arranged these on a white tablecloth with a squat ceramic pitcher and other kitchen objects. He then loaded his palette with paint, took up a variety of large brushes, and described the slimy still life with paint so succulent and juicy that it still looks wet more than a century later. Although Monticelli's aesthetic was rooted in the practice of mid-century painters, who saw color as emerging from a deep brown *ébauche* (underpainting), his sheer love of paint itself and his variable and expressionist brushstrokes had few proponents in his own generation. Indeed, it took an artist with van Gogh's artistic sensibilities to appreciate Monticelli. As if in homage to the master from Marseilles, van Gogh painted several still lifes with sardines while he stayed in Arles a little less than two years after Monticelli's death in 1886.

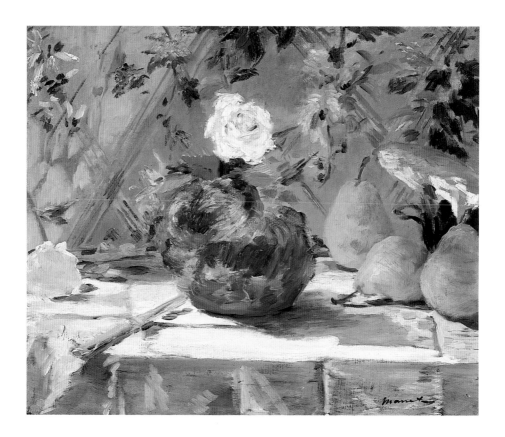

EDOUARD MANET
Brioche with Pears, 1876
Oil on canvas; 18⅛ × 22 in. (46 × 54 cm)
Signed, lower right: *Manet*
66.1985

EDOUARD MANET PAINTED this unusual
still-life subject, a rose stuck in a brioche,
three times in his career. The first ver-
sion (David Rockefeller Collection, New
York) was painted in 1870 in homage to a
still life with brioche by Chardin that had
just been acquired by the Louvre as part
of the famous La Caze bequest in 1869
(see fig.). Manet's canvas is considerably
larger and more luxuriously conceived
than Chardin's modest, careful still life.
Chardin's simple table changes into a
sumptuous Louis XV bureau in Manet's
1870 still life, and other alterations are
equally telling. Chardin's pair of pome-
granates becomes a pyramid of perfect
peaches; his blooming orange branch,
a rose that is just beginning to unfold;
his small Meissen bowl, a wonderful

circular box of chocolates that has just
been opened; his cut-glass bottle of wine
and cherries, a bunch of grapes. And to
all this Manet has added a knife with a
mother-of-pearl handle that has already
cut the ribbon on the chocolates and can
now begin to ravage the peaches and the
perfect brioche.

Manet waited six years before turn-
ing to the subject again in 1876. Adolphe
Tabarant dated this picture and two
smaller still lifes to the fall of that year,
presumably because of the season of
the fruits (Tabarant 1947, 296–97). Ev-
erything about the second version is the
opposite of Manet's still life with brioche
in the Rockefeller Collection. Whereas
the first is dark in tonalities, the second
is full of light. The first is painted with

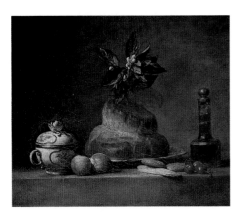

Jean-Baptiste-Siméon Chardin, *La Brioche,* also called *A Dessert*, 1763. Oil on canvas, 18½ × 22 in. (47 × 55.9 cm). Musée du Louvre, Paris. Photograph courtesy Réunion des Musées Nationaux.

a variety of brushes and is variably "finished" depending upon the texture, proximity, and character of the painted object, while the second appears to have been "tossed off" with a loaded brush in an enjoyable afternoon of painting. In place of the dark *ébauche* ground plane in the 1870 version, Manet substituted a garden-style wallpaper with trellis and flower motifs. He covered a table with a pure white creased damask tablecloth that collects and distributes the ample natural light from an unseen window. He also included another flower—perhaps the losing candidate for the throne of the brioche—and an informally arranged group of three not-quite-ripe pears in front of a market basket with a baguette. The telltale knife remains, but this one is described with about ten strokes of paint laid on while wet, in contrast to the carefully constructed knife in the 1870 version.

Manet's 1876 *Brioche with Pears* is all about painterly virtuosity and apparent spontaneity of touch. It is ample testimony to the painter's craft and his ease with the language of painterly gesture. Indeed, one scarcely remembers

Chardin's painting in looking at the Reves *Brioche,* so fully have its lessons of pictorial construction and imagery been internalized by Manet. He took up the subject one more time around 1880, when he painted a pair of still lifes for the Philadelphia physician and dentist Dr. Thomas W. Evans. This vertical still life reduces the subject significantly; the simple brioche with its rose rests in a porcelain dish nearly in the center of the visual field. Gone are the fruits, the knife, and the other elements of the 1870 and 1876 still lifes with brioche.

There has been very little speculation in print about the significance of the unusual subject. Some French families eat a brioche with a rose on Easter morning as a symbol of resurrection, but the seasonal imagery of Chardin's and Manet's canvases argues against such a connection. What, then, is the significance of a single flower in a wonderfully luxurious buttery bread? If it is Christological, as some suppose, it raises the issues of Manet's religious feelings and his way of conveying meaning in his pictures.

This superb Manet still life was acquired by Auguste Pellerin, one of the greatest collectors of modern French painting from the late 19th century. It hung in his Paris house along with thirty-four other works by Manet and the most important collection of paintings by Cézanne formed in the 19th century. There are many fascinating parallels between this 1876 still life by Manet and the exactly contemporary still lifes painted by Cézanne, which were also inspired by Chardin. Because the painting is in a superb state, every subtlety of Manet's vivacious painterly touch can be savored by a connoisseur of painting, just as the brioche and the pears could be savored by a gourmet.

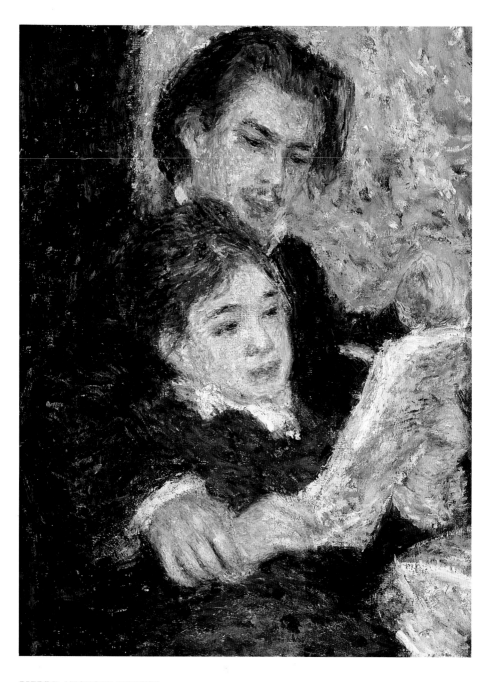

PIERRE-AUGUSTE RENOIR

*In the Studio (Georges Rivière and Marguerite
Legrand)*, 1876–1877
Oil on canvas; 13¾ × 10¾ in. (34.9 × 27.3 cm)
Not signed or dated
1985.R.60

ALTHOUGH IT WAS PAINTED in the mid-1870s, this small painting has all the intimacy of a work by Edouard Vuillard or Pierre Bonnard from the 1890s. Its first owner, Eugène Murer, was a petit-bourgeois collector from Rouen and Auvers-sur-Oise who knew most of the impressionists well and bought important paintings from Pissarro, Renoir, and Cézanne in the mid- and late 1870s. (Renoir painted a superb portrait of Murer in 1877, now in a private collection in New York. By that time, Murer owned ten major paintings by Renoir.) This is among Renoir's most luscious impressionist "souvenirs," and it is clear that Murer knew not only the artist but also his sitters, the amateur critic and bureaucrat Georges Rivière and the artist's model Marguerite Legrand, known professionally as Margot. Thus, this work of art was not made for the anonymous market of urban capitalism but for a small circle of friends whose common interest was art.

Renoir enjoyed painting on this scale in 1876–1877, and he used many of his friends as models for various genre scenes, most of which were posed and painted in the studio. *At the Cafe* (Rijksmuseum Kroeller-Mueller, Otterlo, Holland) and *At the Milliner's* (see fig.) are of virtually identical dimensions and have an equally "graphic" facture. In both, Renoir set up an urban interior situation and painted it not in the city but in his large studio on rue Saint-Georges.

In making a rapid sketch from life, Renoir applied his paint with short, overlapping wrist gestures that very much resemble the strokes of a pencil or crayon. Accordingly, this, like the other small canvases of 1876–1877, has a nervous, wobbly surface that was repul-

Pierre-Auguste Renoir, *At the Milliner's*, 1878. Oil on canvas, 12¾ × 9⅝ in. (32.4 × 24.5 cm). Courtesy of the Fogg Art Museum, Harvard University Art Museums, Cambridge, Massachusetts, bequest of Annie Swan Coburn.

sive to academically inclined critics of the period. Although the linear strokes looked fairly conventional and, hence, acceptable when they described hair or drapery, their convoluted character was antithetical to the conventional depiction of skin.

Georges Rivière, a senior employee at the Ministry of Finance, was a fervent amateur critic of impressionism who appeared in many of the artist's works of the period 1875–1878. He championed not only his hero, Renoir, but all the impressionists, in his journal, *L'Impressioniste,* published weekly during the monthlong run of the impressionist exhibition of 1877. This delightful painting was not included in the impressionist exhibitions of 1876 or 1877, but it was surely painted during those years. Its similarity of facture to Renoir's *Small Female Bather* (Lewyt Collection, New York), painted in 1876, perhaps gives greater weight to the earlier of the two dates.

PAUL CEZANNE
Still Life, 1877
Oil on canvas; 10½ × 13¾ in. (26.7 × 34.9 cm)
Not signed or dated
1985.R.10

PAUL CEZANNE WAS the greatest painter of still life in the 19th century. His only rival as a still-life painter in the history of French art was the 18th-century painter Jean-Baptiste-Siméon Chardin, whose works Cézanne admired throughout his life. This small still life in the Reves Collection has a double identity—its scale suggests a drawing, but its medium and degree of finish belie its modest dimensions. Cézanne made the painting along with a group of three other closely related still lifes (L'Orangerie, Paris; Hermitage, St. Petersburg; Cincinnati Art Museum). All four were done in the same room with the same still-life elements at the same moment in the artist's career.

Most of these paintings are small, and all of them include one or more of the three vessels that form the motif of the Reves still life. These are a glass carafe (perhaps for vinegar or wine), a metal jug (for milk or water), and a ceramic bowl. These vessels were selected because they contrast in every way: one transparent, two opaque; one closed, two open; one matte, two shiny; one horizontal, two vertical; one glass, one metal, one ceramic; one a cylinder, one an elongated sphere, the last a half-sphere; one dark, one light, and the last colorless. These still-life elements present a challenge to the painter and the viewer alike in their contrast, which is set into visual and

conceptual relief by a single fruit: in the Reves still life, a perfectly spherical orange that just touches the metal jug and the ceramic bowl. The fruit is at once utterly "natural" in its origins and utterly artificial in its exoticism. It warms and enlivens a still life that is predominantly cold and gray.

There has been a good deal of disagreement in the prodigious Cézanne literature about the date of this small painting; hypotheses vary from 1877 to 1885. The most persuasive analysis was made by the great English art historian Lawrence Gowing (Gowing 1956). He used both the style of the closely related paintings and the wallpaper in the background to pinpoint the location at which they were painted as Cézanne's Paris apartment at 67, rue de l'Ouest, where he worked in 1877 and again in 1879. Gowing then differentiated between two distinct stylistic groups and dated the group of works in which the Reves still life belongs to the earlier year.

Like the majority of Cézanne's paintings, this still life was left in its current unfinished state by the painter. It was executed on a preprimed canvas of unusual dimensions, and in many areas on both the left and right sides of the composition the primed canvas shines through the thin layers of paint. Cézanne seems to have been most concerned with the center section of the painting, particularly with the relationships among the orange, the jug, and the bowl. Indeed, the interior of the ceramic bowl is as perfectly realized a passage of paint as any in Cézanne's career, its white glaze contrasting completely with the flat black of the adjacent metal jug. Connoisseurs

of painting had to wait two generations until the great Italian painter Morandi investigated still-life effects with equal modesty and expertise.

The Reves *Still Life* was given to the Museum of Modern Art, New York, by the great collector Lillie Bliss at her death in 1931, and was sold in 1950 by the museum, whose collection commences with later paintings by Cézanne. Emery Reves acquired it in 1955.

EDOUARD MANET
Le Bouchon, 1878
Ink and pencil on laid paper; 8¼ × 11⅛ in. (21 × 28.3 cm)
Stamped, lower right: *AB* (conjoined) in a circle
1985.R.35

THIS BRILLIANT brush drawing was made about 1878 as part of Manet's effort to capture all aspects of the urban cafe. It belongs to a small family of closely related works in a variety of mediums, including two pencil drawings and a freely painted oil in the Pushkin Museum, Moscow. In fact, it seems to have been made directly in preparation for the unsigned and undated Pushkin painting, which was possibly sold in Manet's lifetime to the collector Tavernier.

Like many of Manet's brush drawings, this one owes a considerable debt to Asian traditions of painting. Using several brushes that were either "dry" or filled with india ink of various strengths, Manet defined the central figure of a worker seated alone at an outdoor cafe. This figure is shown next to a slumped-over, presumably drunk female, and both are seen behind a prominent tree trunk, which indicates that they are in an outdoor cafe. There have been attempts to identify the setting as either a cafe in the city, on place Moncey, or along the Barrière de Clichy at the edge of Paris. The latter theory seems more likely and has won widespread acceptance. Scholars have also argued over the relationship between this group of works and Emile Zola's novel *The Dram Shop (L'Assommoir)*, published serially to enormous acclaim, and controversy, in 1876–1877. No doubt a real similarity of subject exists between Manet's visual investigation of working-class drunkenness and Zola's literary one, but it would be wrong to interpret Manet's painting as an illustration of any particular passage in the novel. Indeed, whereas Zola treats the world of working-class alcoholism with a grim determinism, relishing its most sordid smells, textures, and sounds, Manet remains aloof. The artist seems to feel an odd respect for the independence of this worker and his snoozing companion. They exist completely in their own world, unaware of the painter/viewer. While Zola's image of drunkenness is noisy and disgusting, Manet's is silent.

Manet never came as close to a proletarian subject as he did in this drawing and its related painting. Neither has played a prominent role in the interpretation of Manet's cafe subjects, possibly because the painting has been relatively inaccessible; it left France early in the century. Both it and this splendid preparatory drawing deserve to be better known.

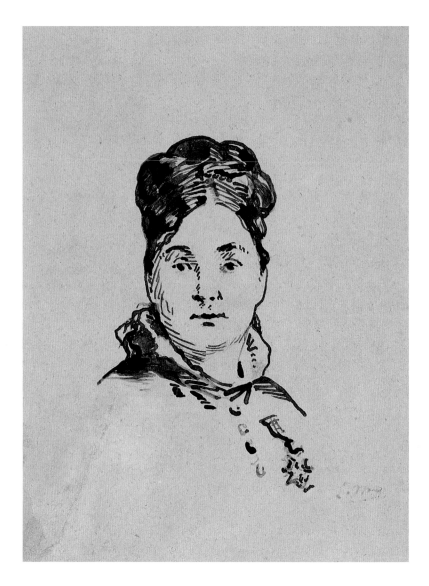

EDOUARD MANET
Portrait of Juliette Dodu, 1878–1879
Pen and ink over graphite on wove paper;
8⁵⁄₁₆ × 6⁵⁄₈ in. (21.1 × 16.8 cm)
Initialed, lower right: *E. M.*
1985.R.32

WHEN IT FIRST APPEARED on the London art market in 1960, this drawing was identified simply as a portrait of a woman. Although in 1962 Pierre Courthion identified the model as Manet's wife, the true identity of the woman is indicated by the Legion of Honor medal that she wears prominently. She is surely the same woman who posed for two closely related drawings formerly in the collection of Camille Pissarro (Rouart 1975, nos. 430–31), identified as Mlle Juliette Dodu, the half-sister of Mme Odilon Redon. Dodu received the Legion of Honor medal in 1878 for her courageous conduct during the Franco-Prussian War.

Manet, who had suffered through the German siege of Paris in 1871, must have known Dodu and made a drawing to commemorate her receipt of the Legion of Honor. The two drawings formerly in Pissarro's collection were acquired at the Manet estate sale. They are smaller than the present sheet and were undoubtedly preparatory to it. In making them, Manet rehearsed his gestures and arrived at the general placement of his vigorous lines. When he had mastered his subject in miniature, he turned to the larger sheet and executed the Reves drawing rapidly over a scaffolding of pencil lines that define the perimeter of the head. Perhaps because the Reves sheet has no provenance before 1960, when it appeared on the market as the property of the great connoisseur-dealer Matthiesen, it was omitted from the 1975 catalogue of Manet's drawings. However, there is no reason to doubt the drawing's authenticity. The verve of execution and the close relationship to the two smaller sheets suggest that it was made for its distinguished sitter and given to her by the artist.

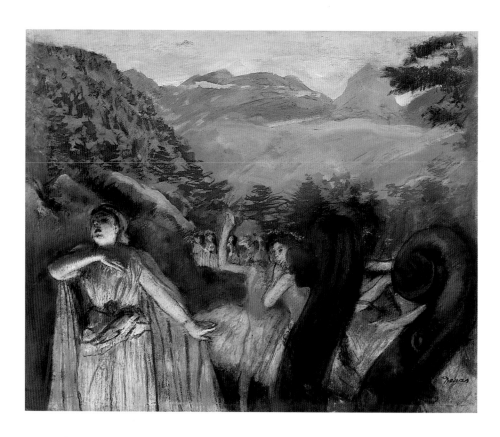

EDGAR DEGAS
Aria after a Ballet, 1878–1879
Pastel and gouache over monotype mounted on cardboard;
23½ × 29½ in. (59.7 × 75 cm) (irregular)
Signed, lower right: *Degas*
1985.R.26

THE DURAND-RUEL FAMILY seems to have bought this splendid painted print by Edgar Degas from the fourth impressionist exhibition of 1879 and kept it in the family collection until Emery Reves bought it in the late 1940s. Thus, it has a provenance that links it to the artist himself and to the collection of the most important Parisian art dealer of the late 19th century. Although it has never been recognized as a print in the vast Degas literature, the platemarks along the left, right, and lower edges make it clear that this large pastel and gouache painting was made over a monoprint. There are no other surviving prints from this immense plate—the largest ever used by Degas—possibly because it was so difficult to print. Perhaps because the impression was inferior, Degas covered the vast majority of the printed surface with pastel and gouache. This alteration, and the relative inaccessibility of the work to scholars, has prevented the identification of the plate.

Physical evidence suggests that Degas made a huge black-ink monoprint, cut the sheet of paper along the top after printing (perhaps because the impression along the top was so bad), and then used the resulting print as the armature for the gouache landscape and pastel figures. He chose the two mediums carefully. The dry gouache has all the qualities of the flat water-based paints that scenery painters used to achieve the best effect of stage lights. For contrast, Degas used pastels for the figures, whose costumes and makeup were designed to pick up and scatter the light.

That Degas selected this complex work of art for inclusion in the 1879 impressionist exhibition indicates the high regard that he felt for it. The impressionist exhibition of that year was dominated by Degas, whose submissions to it were of the highest quality. Interestingly, the scene was identified in the exhibition catalogue as *Le Ballet de l'africaine*. Scholars have never identified the particular opera depicted in this painted print.

PAUL GAUGUIN
Portrait of a Man, c. 1880
Oil on canvas; 10¾ × 7⅜ in. (26 × 17 cm)
Not signed or dated
1985.R.29

THIS SMALL PORTRAIT head has been identified by Paul Gauguin's son, Pola, as a portrait of the painter's paternal uncle, Henri. Although Pola dated the portrait to 1879 in his certificate of authentication, subsequent scholars have given it a later date of about 1884, presumably on the grounds of style. In fact, neither the identity of the sitter nor the date of the painting can be corroborated with other evidence, and in spite of Pola's certainty of tone, it must be remembered that many of his attributions and dates have not held up to modern scrutiny.

Whatever the identity of the sitter, the painting has almost no qualities of a portrait. The man's featureless black eyes project no character and allow the viewer no access. Neither is the figure given any telling details of costume or props that would help us establish his profession or interests. Only his unfashionable hat and simple coat give the portrait character, and that character is generic rather than individual in nature. The slightly hooked nose of the sitter is similar to Gauguin's own, allowing us to infer that the painting represents a member of the family, as Pola asserted. But that is all.

The painting appears to be unfinished. It was painted directly on a primed canvas, which Gauguin used almost as a sheet of paper, allowing it to remain as the background. The unusual size and folded corners of the canvas indicate that it may even be a fragment of a larger composition, cut down later to become a portrait.

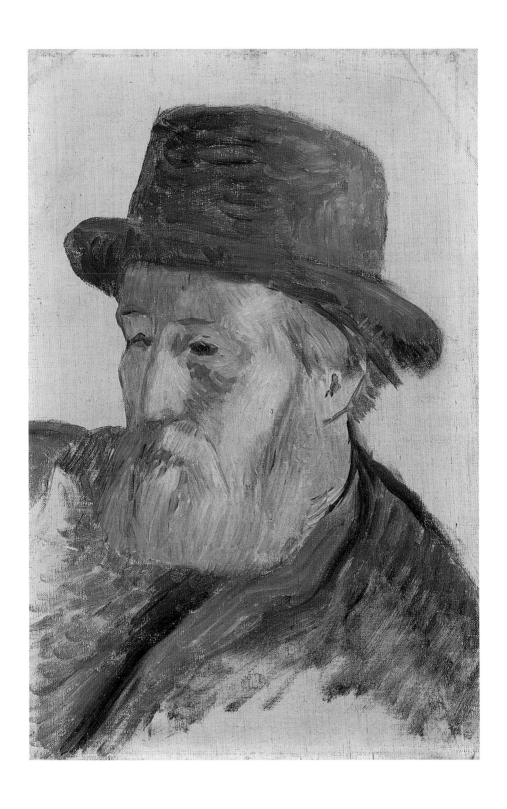

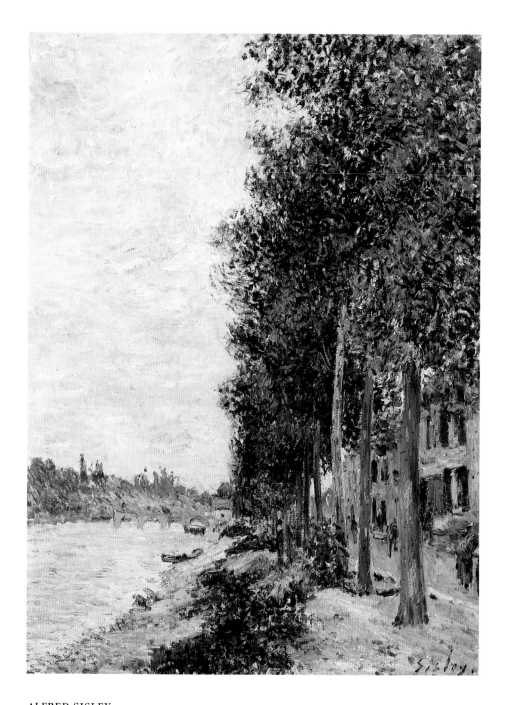

ALFRED SISLEY
Road along the Seine at Saint-Mammès, 1880
Oil on canvas; 29 × 21⅜ in. (73.7 × 54.3 cm)
Signed, lower right: *Sisley*
1985.R.69

LANDSCAPE PAINTERS are cursed by the monotony of the horizontal. Throughout the history of the genre, landscapes have been produced as horizontal compositions of varying dimensions, and only painters of landscapes as architectural decoration have been permitted to experiment with various formats. For Alfred Sisley, the purist among the impressionist landscape painters, this limitation was a particular problem. In 1880–1881, when this work was painted, his friend Pissarro was varying his steady diet of horizontal landscapes with a new series of vertical figure pictures. But Sisley, whose works were only beginning to sell regularly again after four years of comparative poverty, churned out horizontal landscapes, probably because they sold better. In fact, of the 149 canvases catalogued by Daulte from the years 1879 to 1881, only eleven are vertical (Daulte 1959a). It seems that the verticality of the Reves landscape was not a virtue, because after it was purchased from the painter by his friend and major dealer Paul Durand-Ruel in 1881, it failed to sell until 1950, when Emery Reves purchased the picture directly from Durand-Ruel's heirs.

The painting is boldly composed, with the right half devoted exclusively to form, while the left half is dominated by light and space. Thus, the right side is comparatively dark, with only holes of light squeezing through the foliage and architecture. By contrast, the left half is a palpitating visual field of sky and the reflective surface of the Seine, with occasional forms such as boats, a bridge, and the distant banks of the river to make the space legible. Like many paintings from this fascinating and under-studied period of Sisley's career, *Road along the Seine* is antipicturesque. The subject is not the road at all, but rather the messy and unkempt banks of the great river along the road. Furthermore, the picture does not represent this banal site in beautiful light, but on a gray, overcast day.

The date of the picture is in dispute; Daulte, the foremost authority on the work of Sisley, argues for a date of 1881, when the picture was acquired from the artist by Durand-Ruel (Daulte 1959a, no. 425). Emery Reves, in a 1974 letter to the English dealer David Somerset, claimed that a record photograph of the picture from the Durand-Ruel archives in his possession clearly dates it to 1879. Unfortunately, Reves's claim cannot be supported, as the photograph does not survive. The painting was made in Saint-Mammès, a village along the Seine in which Sisley worked extensively in 1880 but never visited in 1879. A masterful horizontal landscape dated 1880 and painted at the same site is in the Sara Lee Collection in Chicago, and the Museum of Fine Arts, Boston, possesses a view of the identical road and group of buildings that is also from 1880. Thus, both Daulte and Reves were wrong, and the evidence allows us to date the picture conclusively to 1880.

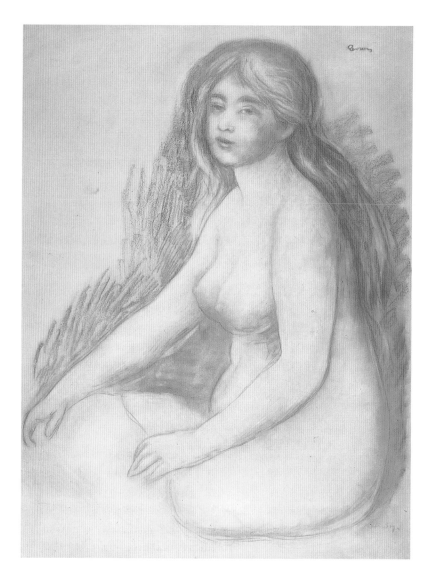

PIERRE-AUGUSTE RENOIR
The Bather, 1880–1881
Red chalk on wove tissue paper mounted on
board; 33¼ × 25⅝ in. (84.5 × 65.5 cm)
Signed, lower right: *renoir;* signed, upper
right: *renoir*
1985.R.57

THIS IS AMONG the most important
surviving drawings by Renoir. It re-
lates, without question, to the famous
painting *Blonde Bather* of 1881 (see fig.).
Renoir is said to have painted this work
in Naples while on his first trip to Italy,
where he studied the art of the ancient
world and the Renaissance, as his fellow
Frenchmen had done since the late 16th

century. Renoir's trip fostered direct con-
nections between his art and the classical
tradition. While in Italy, Renoir studied
Raphael, whom he admired but, as a
true Frenchman, considered inferior to
Ingres. Renoir had moved beyond im-
pressionism by 1880 and sought in Italy
inspiration from great past art. In this
way, his motivations were exactly the

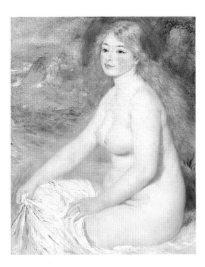

Pierre-Auguste Renoir, *Blonde Bather,* 1881. Oil on canvas, 32³⁄₁₆ × 25⅞ in. (81.8 × 65.7 cm). The Sterling and Francine Clark Institute, Williamstown, Massachusetts.

opposite of those of the founders of impressionism, who stressed an art rooted in daily life and the varied appearances of the modern world.

The Bather has many layers of tradition. First, its subject of a female bather alludes to a long tradition of similar images—Suzannah at the bath, Diana, Venus—that populate Renaissance and baroque painting, drawing, and printmaking. Within this tradition, the nude more often reclines than sits; in creating a seated nude, Renoir allowed the nude an identity as a person, free to move as she wishes. Hence, she is at once mythological and modern. And by giving her a prominent wedding ring, as can be seen in *Blonde Bather,* Renoir made her not only contemporary but also above reproach in her nudity. Thus, Renoir created a thoroughly modern "goddess" who carries within her allusions to both the Bible and classical mythology.

A second fascinatingly traditional aspect of the drawing is its medium—red chalk, or *sanguine* in French. Renoir began using this medium only in the late 1870s and early 1880s; thus, this sheet can be considered his first masterpiece in the medium. The technique has a power-

ful history in French art, with its most important roots in the drawings of 18th-century masters such as Boucher, Pierre, Fragonard, and Robert. Hence, Renoir courted a specifically "French" tradition of drawing while working in Italy.

It is likely that this sheet was drawn from the model in Naples in preparation for the 1881 painting. Renoir apparently began that painting in Naples and, on returning to France, gave it to his friend Henri Vever. When comparing the drawing to the painting, we observe that both figures are of identical dimension, guaranteeing their one-to-one relationship. Although it would be tempting to conclude that Renoir first made the drawing and then transferred it to the primed canvas, there is unfortunately no positive evidence for this. He used heavy wove tissue paper rather than tracing paper and did not "square" the drawing to ease transfer. It is more likely that Renoir made the drawing from the model to secure his knowledge of the figure. He drew initially in pencil, using thin but firm lines to outline all major forms. These he softened and expanded with the red chalk. The drawing was probably finished along with or after the painting. Its two signatures suggest that when he sold it to his dealer, Ambroise Vollard, he signed it more prominently to add to its salability.

Renoir surely consulted the drawing again on making a second painting, in 1882, of the same figure, a version larger than either the drawing or the first painting. This superb second painting (Agnelli Collection, Turin) was formerly in the collection of Sir Kenneth Clark, whose book *The Nude* redefined the way 20th-century viewers think about the unclothed human form (Clark 1956).

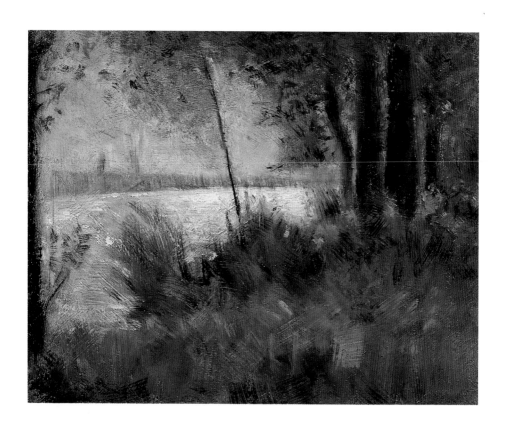

GEORGES SEURAT
Grassy Riverbank, 1881–1882
Oil on canvas; 12¾ × 16 in. (32.5 × 40.7 cm)
Not signed or dated
1985.R.68

THE FIRST OWNER of this mysterious small landscape by Georges Seurat was the famed critic, theorist, and dealer Félix Fénéon, who must have admired its equipoise between the landscape aesthetics of the impressionists, with their love of atmosphere, and the more rigorous pictorial construction of the post-impressionists, of whom Cézanne was the most accomplished. Most scholars have dated the painting to 1881–1882, that is, early in the progressive and developmental career of Seurat. Before conceiving of the large-scale canvases that secured his permanent place in the canon of French painting, Seurat made this painting as an independent study of light, reflection, and vegetation in the Parisian suburbs. Daniel Catton Rich, who included this canvas in his landmark Seurat exhibition, held at the Art Institute of Chicago in 1935, considered it to be the first landscape study painted by Seurat on the island of the Grande Jatte (Rich 1935, 60), where he worked obsessively in the summers of 1884 and 1885. However, no real evidence supports this theory, and the picture is generic enough in its subject that it could have been painted in many parts of the western suburbs of Paris frequented by Seurat.

Unlike the vast majority of landscape studies by the artist, the Reves example was painted on canvas, which Seurat prepared with a white ground and worked with relatively large brushes to give structure to the composition.

After attaining a certain order in the composition and achieving the effects of light and color he sought, Seurat worked "into" the surface with smaller brushes, in the manner of Corot, giving life to the foliage with dancing strokes. There is no evidence in this canvas of his interest in the scientific theories of color that were to dominate his art several years later. Instead, every chromatic element in the picture can easily be found in impressionist painting. But when we compare it to earlier landscapes by Monet, Renoir, Sisley, or Pissarro, the eerie loneliness and social isolation of Seurat's aesthetic come into sharp relief. In Seurat's pictorial universe of 1881–1882, there are no strollers, no boaters, no delightful children running through the fields or playing along the river. Instead, the viewer is encouraged by the composition of the painting to "become" the painter, hidden in a quiet field of long grass, far from the prying eyes of Parisians, working methodically to set down his sensations on a small canvas. It is almost as if we made these brushstrokes ourselves and could alter them with the slightest effort. Yet, for all the immediacy of its touch and directness of its methods, the painting remains mysterious, and even after lengthy analysis, we know a good deal more about the art of painting and very little about the painter. This air of mystery has always been an essential element of Seurat's aesthetic.

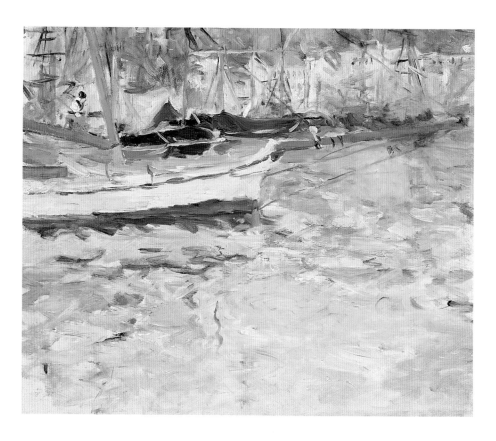

BERTHE MORISOT

The Port of Nice, 1881–1882
Oil on canvas; 15 × 18¼ in. (38 × 46.4 cm)
Signed, lower left: *B. Morisot*
1985.R.40

BERTHE MORISOT and her husband, Eugène Manet (the brother of Edouard Manet), spent the cold winter months of 1881–1882 in the Mediterranean port of Nice at the fashionable Hotel Richmond, where the artist practiced her technique on the most shifting of subjects—the harbor. Although brisk, the weather was warm enough to allow her to work out-of-doors or, at the very least, from her hotel window, as the wonderful light of the French Riviera inspired her to trap its effects on the water in paint. This small painting is among the most successful of the several she made on that campaign, and the artist chose it for inclusion in the penultimate impressionist exhibition of 1882. The paint was barely dry on the canvas when she had it framed and took it to the galleries, where it hung almost like a watercolor amid larger and bolder works by her male colleagues.

The Port of Nice is a study in modesty and apparent carelessness. Its strokes, of varying dimensions, textures, and lengths, force the viewer to think of the representation *as* a painting. Many of her strokes, especially those in the large area of the water, refuse to "represent" anything other than themselves, suggesting that the water was too choppy to reflect the buildings, boats, or riggings. The boldest and most fundamental decisions made by Morisot were about composition, and they were clearly made before she even began to paint. First, she decided to downplay the sky, preferring to study the effect of light on form. Second, she decided to push the boats and buildings into a band at the top of the painting. This led her to order the area of the water by placing the bow of the boat as it enters the water directly at the center of the composition. Hence, the composition is controlled and deliberate, even though it appears to be random.

Morisot's achievements as a painter can be set into relief when one compares this small canvas with the almost exactly contemporary painting by Georges Seurat in the Reves Collection (p. 78). Whereas Seurat's painting is stiffened with an apparent rigor of composition, Morisot's seems inchoate. Yet, just the opposite is true: not a single line or form is placed in a geometrical manner in Seurat's painting, whereas Morisot's canvas is held together with a rigorous logic. For Morisot, the "touch" was informal and the composition was formal. For Seurat, the opposite was true.

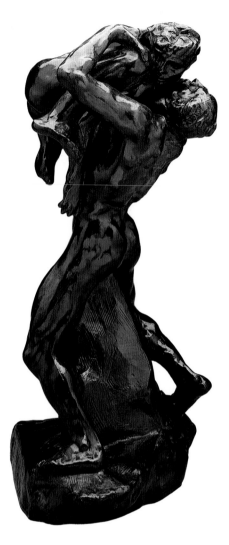

AUGUSTE RODIN
I Am Beautiful (Je suis belle), 1882
Bronze; H. 26⅞ in. (68.3 cm), W. 14⅛ in.
(35.9 cm), D. 12¼ in. (31.1 cm)
Signed: *A. Rodin;* poem inscribed on base
1985.R.66

JUST AS EDGAR DEGAS created human
figures in wax, used them as models for
drawings, traced the drawings to reverse
them, and combined the figures with
others to create groupings, so did
Auguste Rodin create, reuse, and re-
combine figures to form new works of
art through varied juxtapositions. *I Am
Beautiful* is among the more brilliant of
the works that result largely from internal
borrowing. Each of the two figures that
twist in Rodin's fictive world derives
from a separate source, and each was
used in various ways in other works. The
female figure, in a crouching, almost fetal
position, is embraced by a standing man
who seemingly reaches to the heavens
to rescue her. Derived from *The Crouch-
ing Woman,* the female figure was stud-
ied separately by Rodin and included
in his most orgiastic work, *The Gates of
Hell* (final assembly 1917, Musée Rodin,
Paris), where she appears on the tympa-
num to the left of *The Thinker.* The
male figure, who appears to rise from
the bronze base in *I Am Beautiful,* is
The Falling Man in *The Gates of Hell;*
there he plunges into hell from under-
neath the lintel at the top left of the great
bronze doors. In uniting these figures,
Rodin created a juxtaposition of oppo-
sites—female and male, closed and open,
falling and rising, fetal and erect. This
ritual conjoining occurred in a plaster
dated 1882, used in turn as the basis for
the Reves bronze, which was cast in a
small edition. Other examples of the
bronze can be found in the Rodin Mu-
seum of the Philadelphia Museum of Art,
the Kunstmuseum in Helsinki, the Na-
tional Museum of Western Art in Tokyo,
and the Musée Rodin in Paris.

Even during Rodin's lifetime, the
work has been known by several titles,
the variety of which indicates that the
sculpture's meanings are unclear. It
seems that the work was first exhibited
as *The Rape* when it was shown in 1899
and 1900 in exhibitions conceived under
Rodin's direction. It was also shown as
The Cat and *Carnal Love.* The bronze

version, however, was later cast with a lengthy inscription from Baudelaire's poem "La Beauté" ("Beauty," in *Les Fleurs du mal*):

> *Je suis belle, ô mortels! Comme un rêve de pierre,*
> *Et mon sein, où Chacun s'est meurtri tour à tour,*
> *Est fait pour inspirer au poëte un amour*
> *Eternel et muet ainsi que la matière.*
> (Baudelaire 1961, 20)

> I am beautiful, oh mortals, like a marble dream,
> And my breast on which each sacrifices himself in turn,
> Was made to inspire poets with a love
> As eternal and silent as matter.
> (Trans. Julie Lawrence Cochran)

For unknown reasons, Rodin changed the last line of Baudelaire's masterpiece to *"Etant alors muet ainsi que la matière"* (So being mute as matter), making the quatrain unclear.

What did Rodin mean in presenting us with this powerful image? The great Rodin scholar Albert Elsen felt it was the chance coupling of figures in the artist's studio that created "this striking union," one that Rodin himself only slowly came to understand verbally (Elsen 1985, 83). As is often the case, he chose a literary analogue that is as ambiguous as his forms. The verse acts as a cipher for the mystery at the core of the sculptural enterprise as practiced by its greatest 19th-century exponent. In its commingling of violence and empathy, restless movement, and evocation of a famous poet, whose early death from syphilis in 1867 came as a shock to vanguard artists, *I Am Beautiful* embodies a difficult notion of beauty.

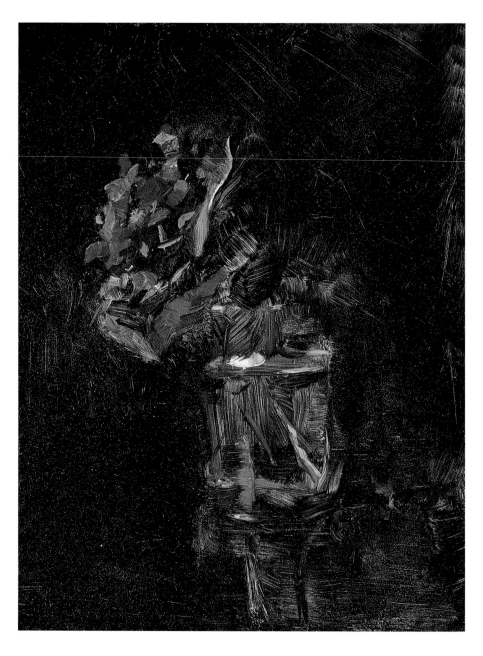

HENRI DE TOULOUSE-LAUTREC
Bouquet of Violets in a Vase, 1882
Oil on panel; 9⅜ × 7⅜ in. (23.8 × 18.8 cm)
Not signed or dated
1985.R.77

THIS DELIGHTFUL subtle still life was painted when the artist was only eighteen years old, before he became certain of his profession as a painter. Its subject, a bunch of violets, has precise connotations to the French; men often bought small bouquets of fragrant violets from street vendors as gifts to women. Manet, Morisot, and Cassatt had already depicted them when Henri de Toulouse-Lautrec started this small painting. Given its imagery, the painting could be interpreted as a pictorial offering to a loved one or friend, except for the lack of an inscription and the fact that its first owner, Dr. Viau, was a prominent collector. The background of the painting is a freely brushed field of dark brown *ébauche* (underpainting) over white priming, and the forms of the glass and the flowers appear to have been defined in this paint while it was still wet. The delightfully gestural handling seems to be an attempt by the young painter at a tour de force, but he failed to achieve the elegance and ease of his hero, Edouard Manet, who was creating floral still lifes at the same moment, at the end of his career.

The dimensions of the panel suggest that it, like most of the panel paintings by Georges Seurat, was painted on a cigar-box top. Many vanguard artists liked this material because such panels were readily available and were made of absolutely flat, excellent cured wood. In addition, the relatively small size of these panels allowed them to be packed easily for an outdoor oil sketching adventure.

ODILON REDON

The Port of Morgat, 1883
Oil on paper mounted on canvas;
10⅝ × 11⅝ in. (26 × 28.5 cm)
Signed, upper right: *ODILON REDON*
1985.R.53

ODILON REDON is known primarily as a painter of dreams and of the human imagination. His representations abound in floating eyes, chalices filled with liquid, disembodied heads, chariots with rearing horses, and cyclopes. Yet, as with all great artists of the visual imagination, his art was grounded in a study of nature. This wonderfully melancholic landscape was painted in 1883, on Redon's second trip to the coast of Brittany. Redon was attracted to Brittany because of its mystery, its Breton language, and its "primitive" people and customs. He referred to Brittany as a "marvel of solitude and sadness" in a letter written to his friend Emile Hennequin in the town of Crozon, where he was staying (Auriant 1935, 2).

The fishing village of Morgat is located about two miles from Crozon, and Redon visited it many times during his stay in Brittany. When walking to Morgat, he often took both a sketchbook and a small drawing board, and worked to transcribe the buildings, rocks, dunes, and people of this desolate part of France. (A sketchbook and several painted studies from these trips are now in the Musée d'Orsay, and other painted studies can be found in the Woodner Family Collection, New York.) Of the landscapes from 1883, the Reves picture is the largest and most complete, representing in one work several motifs that Redon had already studied separately: the rocks, the fishing boat, and the granite-walled houses of the village. As is always the case with Redon's painted landscapes, this scene is unpeopled; thus we are not allowed to identify with the landscape or to know how distant or how large it is. The town itself has a muffled presence in the landscape, which seems more insistently directed to the boat, the reflective water of the port, and the great black rock of the foreground. The very part of the port that should be populated and alive is hidden from us by the large rock. Redon also chose to represent the scene in an odd, irrational light. The sky is a spaceless blue, populated by large, heavy clouds. Although the sky clearly provides light to the landscape, Redon constructed the picture so that the lightest areas are not above, but in the reflective surface of the water in the center. And by casting a dark shadow over the entire foreground, he further exaggerated the brilliance of the light on the water.

The painting can be interpreted as a sequence of hidden and mysterious forms, none of which can be clearly defined. The fishing boat is beached, the village deserted, the port empty of activity, the beach dark, and the sky filled with wind. A tiny windmill churns on a distant hill, an emblem of isolation and endurance.

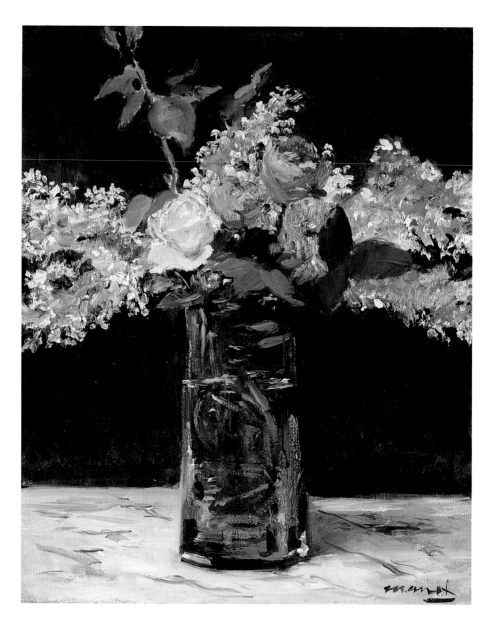

EDOUARD MANET

Vase of White Lilacs and Roses, 1883
Oil on canvas; 22 × 18½ in. (55.9 × 46 cm)
Signed, lower right: *Manet*
1985.R.34

MANET SPENT THE LAST two years of his life in a painful convalescence, worn down by the debilitating effects of various physical ailments. His major achievement of those years was *The Bar at the Folies-Bergère* (1881–1882, Courtauld Institute, London), which is arguably his masterpiece. He also painted a wonderful group of garden landscapes at a rented summer home in Rueil as well as a superb series of simple floral still lifes, now scattered in collections throughout the world. *Vase of White Lilacs and Roses* is among the freshest and finest of these paintings, all of which speak to the eloquence, refinement, and delicacy of Manet's aesthetic. Never do we have a hint of pain or suffering. Never are we allowed a glimpse of Manet's reflection in the glass vases, or a glance into the rooms in which he painted while enduring the physical sufferings of his last years. Instead, we see the purest of water, the freshest of flowers, and the most exquisitely transparent of glass vases.

Some scholars have followed Adolphe Tabarant's lead in saying that this picture was in fact the second to last painting made by the artist, painted on the last day of February 1883 (Tabarant 1947, 468). Manet died on 30 April after a month of intense pain and suffering. His last painting, a portrait of the actress Méry Laurent, remained unfinished on his easel.

Emery Reves and many others saw the form of a crucified Christ in the lilac branches and the roses. Whether or not one accepts this notion, there is in the work a sense of the ultimate eloquence of gesture, as the flowers reach across the canvas and beyond its edges in their zeal. And Manet's painted gestures have a similar effect; one can read them as either the delicate petals of hothouse flowers or the repeated jabbings of an artist desperate to communicate, but severely restricted in his strength.

PAUL CEZANNE
Abandoned House near Aix-en-Provence, 1885–1887
Oil on canvas; 25⅝ × 32⅜ in. (65.1 × 82.2 cm)
Not signed or dated
1985.R.11

PAUL CEZANNE'S LANDSCAPE paintings are often centered on houses, virtually all empty, abandoned, or ruined. But with the irony common in Cézanne's oeuvre, these dwellings provide a stable center to the landscapes in which they are placed, almost as if they will be re-populated later. Cézanne's "romance" with empty houses began in 1873–1874, when he painted the famous *House of the Hanged Man* (Musée d'Orsay, Paris), which was among his submissions to the first impressionist exhibition of 1874. The rugged canvas represents an inaccessible house, its door closed, its windows shuttered. Cézanne's title for the painting tells us this is the empty house of a suicide victim, whose death-in-sin forever haunts the house and Cézanne's painting of it.

Although it lacks a narrative title, the Reves *Abandoned House near Aix-en-Provence* has all the mystery of *House of the Hanged Man.* No curtains, no shutters, no doorknob, no houseplants give life to this abandoned house, and its central position in a landscape with no additional architecture makes it seem all the emptier. Its isolation is further enforced by Cézanne's decision to deny the viewer any access. The blank doorway is blocked by a stone wall and a large earthen mound, and no pathway is visible. The area surrounding the house is neglected and overgrown.

The dwelling Cézanne depicted in this painting is called a *mas* in the Provençal language. With roots in Roman architecture, *mas* abound in Provence and provide a link between the contemporary countryside of the region and the remote ancient civilization that left such an enduring mark on it. Traditional *mas* are cubic masses of stone with low-pitched gabled roofs covered with half-cylinder tiles. The structures' openings are small and tend not to be placed on the north side. This one seems to be represented from its south facade, on which the doorway and the largest window were customarily placed. A *mas* is at once contemporary and timeless, and in painting it, Cézanne removed all traces of human life to suggest a kind of rural time that the French traditionally call *la longue durée.*

Abandoned House near Aix-en-Provence is among the most carefully composed paintings Cézanne made in the mid-1880s, when he combed the countryside near his hometown of Aix-en-Provence for rural motifs. In painting it, Cézanne borrowed from his teacher Pissarro a standard compositional device, the simple division of the canvas by thirds and halves, both vertically and horizontally. The south facade of the house fills the central third of the canvas and serves as the visual analogue of the canvas. Cézanne used brushwork called the "constructive stroke" to build his composition; these vertical and diagonal strokes were applied in groups, as if they were pictorial "bricks." In this way, both the subject of the painting and its pictorial language relate to architecture.

This painting was in the collection of Dr. Albert C. Barnes, the eccentric Philadelphia collector whose group of nearly 100 works by Cézanne is the most important ever formed in this country. Although the painting was featured prominently in his book *The Art of Cézanne* (Barnes 1939, 224, as *The Yellow House*), it was sold by the Barnes Foundation in 1950 and acquired by Emery Reves in 1956 from the Swiss dealer Siegfried Rosengart. Close analysis of the painting suggests that a good deal of the sky, particularly above the house, was painted over, probably by a dealer early in the century, to minimize the "unfinished" quality of the picture. This unfortunate overpainting cannot be removed without risking damage to the original surface. If one mentally removes the heavy overpainting, the sky has a lightness and transparency that contrasts even more strongly with the massive architecture of the house and the disciplined constructive strokes of the surrounding vegetation.

HENRI DE TOULOUSE-LAUTREC
The Last Respects, 1887
Ink and gouache on wove paper; 25¾ × 19⅜ in.
(65.5 × 49.2 cm)
Signed, lower left: *HTreclau*
1985.R.76

H. TRECLAU IS AN ALIAS that Henri de Toulouse-Lautrec used for a brief period in 1886–1887, and this large sheet is among the masterpieces he signed with that pseudonym (an inversion of "Lautrec"). *The Last Respects* was commissioned by the infamous cabaret singer, poet, and political organizer Aristide Bruant and was used as the cover illustration for his irregular journal, *Le Mirliton* (vol. 2, no. 34, March 1887). Le Mirliton, which means both "toy whistle" and "doggerel verse," was also the name of a cafe founded by Bruant in 1885 as a haunt for radical workers, artists, and dissident members of the bourgeoisie. In associating with the cafe, Toulouse-Lautrec turned his art to the service of the activists, and even this early sheet— among his first mature works of popular art—linked his production with the greatest French graphic artist in this radical tradition, Honoré Daumier.

Unlike Daumier, who made his own lithographs, Toulouse-Lautrec created a drawing, using black and blue inks as well as white gouache. The drawing was then transformed into a print with photographic techniques in which the artist played little part. Indeed, a good deal of the drawing's subtlety was lost when it was transformed into a print. The blue ink (now faded to dull gray) used for the contours of the worker, who wears the customary blue *blouson,* and for the street and streetlight became black in the print. Thus, the dramatic black reserved for the hearse, the horse, and the few mourners who accompany the deceased on his last journey was indistinguishable in the print from the blue of the worker.

Unfortunately, we shall probably never know what Toulouse-Lautrec meant by this scene. Since it is utterly unrelated to the contents of the particular issue it adorned, we are forced to turn to the drawing itself for our interpretation. The large scale of the worker makes him appear almost heroic in relation to the tiny caricatural figures in the distance. His nobility of form and the seeming humility of his gesture might suggest that he knew the deceased, perhaps as an employer, and is paying his respects. However, given the radical politics of Bruant's journal, a more likely interpretation of the drawing is that it represents a heroic worker paying his respects not to the death of a particular man but, rather, to the death of the entire bourgeois class. When considered in this way, the distance between worker and capitalist serves to indicate the passage less of time than of history.

As an aristocrat who loved to "slum," Toulouse-Lautrec was an ideally dispassionate observer of the class structure of Third Republic Paris, and this drawing is perhaps as much proof of his seemingly radical politics as of his ambivalence to the changes in society that he saw as inevitable. How one would love to know the identity of the model for this worker and, in so doing, to understand the depth—or shallowness—of Toulouse-Lautrec's radical politics. Perhaps he made this political work under the pseudonym of Treclau to ensure that his aristocratic family would not be embarrassed by the views espoused in the journal. Yet, oddly enough, there are almost equal measures of subservient respect and mastery in the central figure, guaranteeing that the painter could explain his creation even to his conservative father, should he ever have chanced to see it.

VINCENT VAN GOGH

Cafe Terrace at Night, 1888
Reed pen and ink over pencil on laid paper;
24⅝ × 18¾ in. (62.8 × 46.8 cm) (irregular)
Not signed or dated
1985.R.79

CAFE TERRACE AT NIGHT is a free transcription in reed pen and ink of a painting of the same title now in the Rijksmuseum Vincent van Gogh in Amsterdam. Van Gogh painted the work in September 1888 and wrote ecstatically about it to his sister, Wilhelmien: "So there you are, an evening scene without black, but only beautiful blue, violet, and green, and in this setting the lit square is a sickly pale lemon-green. It gives me great pleasure to paint the evening on the spot" (van Gogh 1958, vol. 3, 444). Oddly enough, he chose this scene, which he described sheerly in terms of color, to be translated into a large-scale drawing in black and white. The Reves sheet is among the very greatest of the reed pen drawings by van Gogh because the artist succeeded in displacing the energy of color with an energy of line. His repeated jabs, wiry curves, bundles of lines, and solid linear compartments give the drawing a verve and directness not present in the painting, and a sense of emotional involvement in the city of Arles that is rare in van Gogh's painted oeuvre.

The cafe shown by van Gogh exists today at the heart of Arles, more or less as it did in 1888, a short walk of ten to fifteen minutes from the artist's house outside the city walls. In walking with his easel, brushes, palette, and paints, van Gogh made a sort of pilgrimage to the part of Arles favored by tourists.

When he arrived at the small square on which the cafe is situated, he set up his easel at some distance from the cafe itself, which he represented as a warming glow of yellow light in a sea of dark blues, greens, and colored grays. Because of his remote position from the cafe, his motif has the quality of a destination, a place of warmth in which to stave off the night.

When van Gogh later translated the painting into a line drawing, his subject was not the actual cafe that he had depicted, but the painted representation of it. Perhaps because the shy artist was not present at the scene when he made the drawing, he was able to move into a closer position, nearer the pool of light that spreads beneath the canvas awning. In doing so, he omitted a good deal of the night sky, all of the trees in the nearby square, and most of the shop immediately adjacent to the cafe. In the drawing, the cafe has grown to encompass a considerably larger portion of the pictorial field, and the empty chairs and table arranged at the front of the cafe seem to beckon us to sit down, order a drink, and relax in the warmth of the light.

Like many of the most important works by van Gogh, this sheet has a German provenance. It was owned by the great scholar Hugo von Tschudi, director of the Nationalgalerie in Berlin. Emery Reves purchased the sheet from the Zurich art dealer Dr. Peter Nathan.

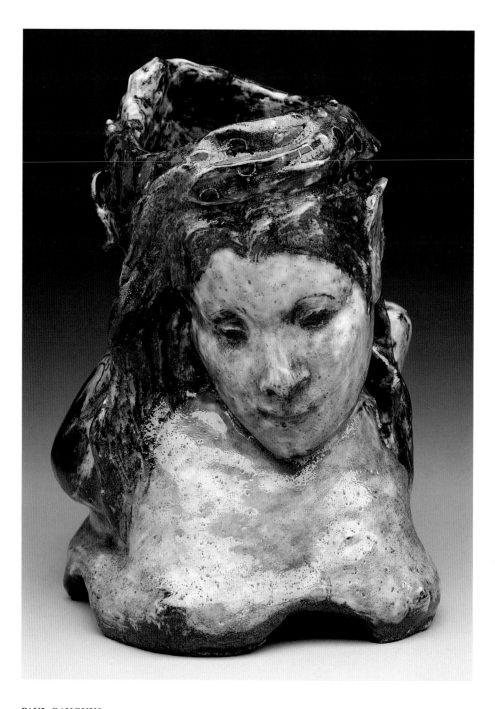

PAUL GAUGUIN
Vase in the Form of a Woman's Head, Mme Schuffenecker, 1889
Glazed stoneware; H. 9½ in. (24.2 cm), W. 6⅝ in. (16.9 cm),
D. 7 in. (17.8 cm)
Not signed or dated
1985.R.28

IF PAUL GAUGUIN had produced no paintings, he would still be given a special place in the history of modern sculpture. Throughout his career, Gauguin created works in the most "primitive" or "direct" of sculptural materials: earth (ceramic) and vegetation (wood). In the first medium, he compared himself—as he often did in paintings—with God, molding human forms from the earth. Of the surviving ceramic vessels (he likely made at least twice as many as are known today), this "portrait" vessel is among the most original and accomplished.

The vase has traditionally been read as a portrait of Louise Schuffenecker, the wife of its first owner and the central focus of a famous group portrait of the Schuffenecker family painted in 1889 (Musée d'Orsay, Paris), the same year that this vessel was made. If this identification is true, Mme Schuffenecker has been transformed from the despondent bourgeois woman of the painting (she is literally swathed in clothes) to a pale nude, whose disembodied hand provocatively arranges the ribbon in her hair. Indeed, the frank sexuality of the ceramic woman is everywhere stressed by the artist. The head and upper torso rest confidently on her large, curved breasts; her ear is shaped as a faun's; and on the vessel itself Gauguin incised a long snake coiled in a tree. Clearly, this woman is a temptress, and Gauguin relates her to Eve, making overt associations between the ribbon in her hair and the serpent in the tree.

The seemingly idiosyncratic design of a bust as a vase did not originate with Gauguin. The painter derived the idea from ancient Peruvian ceramics, particularly those of the Moche culture (c. A.D. 100–700). He knew these ceramics both from his own childhood in Peru and from the collection owned by his great-uncle Isidore, who raised him after the family returned from Peru to France. Yet, as is always true for great artists, the source is completely subsumed by Gauguin, who felt no need to be slavish or to "quote" from a single reference. While the form itself was created by Gauguin, the luscious glazing might have been done in the studio of, and possibly under the direct supervision of, the ceramicist Ernest Chaplet, with whom Gauguin worked in the spring of 1889. The use of metallic, flowing, richly colored glazes makes this work as masterful as any produced in France during the late 1880s. There is little evidence in Gauguin's earlier ceramic production that he had this degree of skill.

VINCENT VAN GOGH
Sheaves of Wheat, 1890
Oil on canvas; 19⅞ × 39¾ in. (50.5 × 101 cm)
Not signed or dated
1985.R.80

ON 17 JUNE 1890, Vincent van Gogh received a large shipment of canvases and paints from his brother Théo. He had been in the small town of Auvers-sur-Oise since 20 May, remaining under the sympathetic care of the homeopathic physician Dr. Paul Gachet. Although plagued with physical and psychological problems, van Gogh continued to produce works at a fantastic rate. From the time that the shipment of canvases arrived until his suicide at the end of July, van Gogh painted thirteen large canvases of a double-square format. These works are unique in his career for their format and for the fact that they seem to be a series. All but one of the double-square canvases were painted with horizontal landscapes (the thirteenth is a vertical portrait of Mlle Gachet at the piano, Kunstmuseum, Basel).

From the evidence of its subject, the Reves *Sheaves of Wheat* is among the latest of this group. The wheat harvest in the region of Vexin, in which van Gogh

painted, occurs from mid- to late July, and earlier that summer van Gogh had painted a field of ripe wheat on the verge of harvest, in his famous *Crows over the Wheat Field* (Rijksmuseum Vincent van Gogh, Amsterdam). The Reves painting seems to have been made as part of a sequence of canvases detailing the wheat harvest, beginning with *Wheat Field under Cloudy Sky* (Rijksmuseum Vincent van Gogh), progressing to *Crows over the Wheat Field* and *Sheaves of Wheat*, and concluding with *Field with Haystacks* (private collection).

Sheaves of Wheat focuses intently on the interrelationship of eight sheaves viewed close at hand. Rather than looking over a distant field, as is usually the case with harvest landscapes, the viewer is immersed in the field, almost as if to approximate a worker's perspective. The sheaves themselves are immediate and palpable, and we are encouraged to think of them as being freshly cut, to revel in the scent of ripe wheat. As if to

emphasize this element of sensual fecundity, van Gogh bathed the entire work in yellow light, lighting yellow with yellow. The distant sky seems filled by the sunlight at the day's very end. This effect of yellowness is emphasized by van Gogh's use of the precise color-opposite of yellow—an intense lavender—for shadows and for the earth in the adjacent field.

Van Gogh's painting of sheaves conveys the sense of a group or family portrait. Each bundle of wheat bends, distributing its weight in an individual way; each appears to nod or pose for the painter. This individuality clearly contrasts with the collectivity of the wheat field from which they are cut, and from the domestic unit of the haystack (almost like a loaf of country bread), which replaces them. Interestingly, Pissarro, who had lived in nearby Pontoise a decade earlier and helped arrange van Gogh's stay with Dr. Gachet, painted these fields during the grain harvest almost twenty years before. Daubigny, whose house van Gogh painted twice, at the same time and in the same format as the

Sheaves of Wheat, had worked in these fields before his death in 1878. The universal symbol of the grain harvest has appealed to landscape painters throughout the history of the genre, but no artist ever achieved a "group portrait" of wheat sheaves that can match van Gogh's late masterpiece in intensity and quality. Like all the other double-square canvases, it remains unsigned. No signature was necessary.

It is tempting to conclude that these last paintings were conceived as a decorative ensemble. Van Gogh might have intended them—or some of them—for the salon or dining room of his patron and physician, Dr. Gachet, as Pissarro's 1873–1874 series of similar harvest pictures had decorated the dining room of the great collector Achille Arosa. Sadly, van Gogh died before clarifying their collective aim, and, like the works intended to be grouped in specific rooms in van Gogh's house in Arles, the canvases from this set have been scattered around the world.

CAMILLE PISSARRO
Landscape at Eragny, 1890
Watercolor, gouache, and graphite on wove paper;
9¾ × 12¼ in. (24.8 × 26 cm)
Dated and inscribed in pencil, lower left:
Eragny 1890 C. Pissarro
1985.R.48

ON 14 JANUARY 1891, Camille Pissarro wrote to his eldest son, Lucien: "I have mounted my watercolors on loose paper so that I can make various series in portfolios. Do you think I should exhibit them? It will cost me too much to mount them, I think. I have one hundred sixty-one. Georges [Lucien's younger brother] finds them more beautiful than my paintings" (Rewald 1981, 177).

Landscape at Eragny is surely one of those watercolors, and of the small number of these masterpieces that have been published, it is among the finest and best preserved. Pissarro was at a critical point in his long career in 1890, when he made this and most of the other watercolors referred to in the letter. His production of paintings, which was hampered by the laborious technique of neo-impressionism, had dwindled considerably (he produced only eight dated canvases in 1889 and fifteen in 1890). In addition, his income was minimal, not only because he had produced fewer paintings but because amateur collectors had not responded to the "dotted" technique of the neo-impressionists. For Pissarro in 1890, it was critical to make money and rethink his position as a painter. He seems to have done this by using the medium of watercolor, at which he was an acknowledged master.

From the windows of his farm home and studio in central Normandy, Pissarro consoled himself by painting scores of landscapes—in rain and snow, in fog and mist, at dawn and sunset, in every season. In each, the landscape forms are arranged in bands parallel to the picture plane, and the effects of atmosphere, light, and time intercede, giving their particular character to what was in reality a monotonous landscape motif. These watercolors record his moods and embody his constancy of vision in this very difficult year.

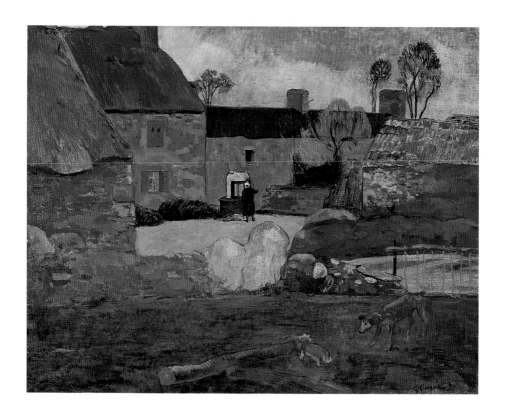

PAUL GAUGUIN
Farm at Le Pouldu (The Blue Roof), 1890
Oil on canvas; 28 × 35½ in. (71.1 × 90.2 cm)
Signed and dated, lower right: *P. Gauguin 90*
65.1985

LE POULDU IS A tiny coastal fishing and farming village that became a tourist town in the last quarter of the 19th century. Small hotels and inns opened, and farmers let rooms to adventurous urbanites eager to escape the pressures of France's newly industrial cities. Because Le Pouldu was inaccessible by rail, and so never developed into a major center, it was an attractive place for intellectuals, artists, and other impecunious members of the European avant-garde. Paul Gauguin had worked there in 1889, with his friend the Dutch painter Meyer de Haan, and spent a good deal of 1890 there because he failed to earn a sufficient income to live in Paris.

Farm at Le Pouldu represents a beautiful traditional farm that can be reached by a small path running from Le Pouldu. It had been painted by de Haan in 1889 (Rijksmuseum Kroeller-Mueller, Otterlo, Holland), and Gauguin may have used the earlier painting as the basis for his 1890 work, since the two are virtually identical in composition. However, it is more likely that the two painters worked on their canvases simultaneously and that Gauguin, always painstaking in his working methods, simply took longer to finish his version. The bright green winter grass, barren trees, orange foliage, and slate gray sky identify his work as a late autumn landscape.

How different Gauguin's farmyard is from those found in French painting, from the rococo works of Boucher to Pissarro's landscapes. For most artists depicting agrarian life, the farmyard is a scene of familiar rustic activity and a kind of primitive sexuality—birds and animals cavorting in a space shared by the farmer and his family. In Gauguin's farmyard, all these associations are banished. A lone farm woman draws water from the distant well, oblivious to the painter/viewer. There is no visible door or entrance to the compound. Instead, Gauguin situates himself and the viewer outside this rural world, emphasizing by every available means the distance between the urban observers of his painting and the world that they contemplate. The confrontation of the dogs in the foreground is a visual analogue of this distance: a vigorous rural dog confronts a tiny urban lap dog near two recently sawed logs. Gauguin the fabulist, the master of irony, the sardonic jokester, mocks viewers with these two dogs, turning us into the helpless lap dog.

Gauguin's *Farm at Le Pouldu* is filled with mystery and uncertainty. The little joke of the dogs does not help to explain the white puff of smoke in the foreground, the flaming orange foliage on the tree in the courtyard, and the oppressive walled enclosure of the farm. The chromatic structure of this painting is among the most fascinating and resolved of any conceived by a French painter in the generation following impressionism. Gauguin's colors are neither natural nor completely artificial, and he makes sure that we know how little interest he had in the scientific and optical color theories of his contemporary Georges Seurat. In this way, the painter was antitheoretical and "synthetic" in his approach. *Farm at Le Pouldu* is undoubtedly the greatest landscape painted by Gauguin in 1890, and it was equaled in quality only once or twice before Gauguin's death in 1903. It may have formed the central part of a Le Pouldu triptych with *The Haystacks* and *Landscape at Le Pouldu*, both in the National Gallery of Art, Washington, D.C. Unfortunately, these three canvases have never been grouped together.

MAXIMILIAN LUCE
The Thames at Vauxhall Bridge, 1892
Charcoal on wove paper; 7¾ × 9¾ in. (19.5 × 25 cm)
Not signed or dated
1985.R.31

MAXIMILIAN LUCE was suffering immensely just after his wife left him when Camille Pissarro, always the father figure, invited Luce to travel to London with him to visit his son Lucien. Pissarro made the suggestion out of respect for Luce, whose neo-impressionist paintings of the late 1880s and early 1890s are the pinnacle of his modest contribution to vanguard painting. Luce accepted the elder painter's invitation and spent June and July of 1892 in London (Bouin-Luce 1986, vol. 1, 25, 71). There the three men went frequently to museums and studied paintings, especially the works of Turner, whose views of the Thames they must have admired. As if in modernist mimicry of the great British master of color, both Pissarro and Luce decided to paint the Thames and her great bridges.

Luce made this powerful charcoal drawing sometime during the summer of 1892 and, perhaps immediately, used it to form the compositional scaffolding for an important painting that he completed in 1893. The painting, *The Thames in London, Vauxhall Bridge* (private collection, London), was first exhibited in 1894, but the drawing for it is reproduced here for the first time. Many connoisseurs of Luce's career find that his greatest works are his charcoal drawings of the late 1880s and early 1890s, and Emery Reves evidently concurred.

PIERRE-AUGUSTE RENOIR
Portrait of Camille Pissarro, 1893–1894
Black chalk on wove paper; 12 × 9⅜ in. (30.5 × 23.9 cm)
Signed, right center: *a. renoir*
1985.R.63

PISSARRO AND RENOIR were drawn together because of their mutual respect for and friendship with Paul Cézanne. This portrait of Pissarro by Renoir is one of the rare documents to survive from their friendship during the 1890s. After the men became independently successful, and their marriages, families, and careers took them to different parts of France, their encounters were rare and often ceremonial. It is therefore impossible to date this sheet with precision. Physically, Renoir's Pissarro resembles the bearded elderly man of the older painter's own dated self-portraits of 1898 and 1903. The only "fashion clue" in the portrait, the beret, was worn by Pissarro throughout his life and thus lends no information to help date the picture. Fortunately, the Reves Collection contains one of only four surviving self-portraits by Pissarro (p. 126), and the two works resonate quietly. If Pissarro's is a self-analysis, Renoir's small portrait is a record of the friendship, made quickly, signed, and, without doubt, given to its sitter. One wonders whether Pissarro made a drawing of Renoir at the same time.

Pissarro died in 1903, more than thirteen years before Renoir's death. The two men had come together again as friends after a rupture that took place in the late 1880s, when Pissarro took up the cause of Georges Seurat and young neo-impressionists against what he considered the romanticism of Monet and Renoir. As Pissarro himself abandoned neo-impressionism in the early 1890s, he was once again welcomed by the dealer Paul Durand-Ruel, who maintained a close relationship with Renoir. The two artists worked together in settling Gustave Caillebotte's estate in 1894 and saw each other at rare intervals throughout the 1890s. Since Pissarro spent increasing time each year in Paris, his chances to see Renoir multiplied. Because no letters between the two men survive from those years, the drawing is all the more precious.

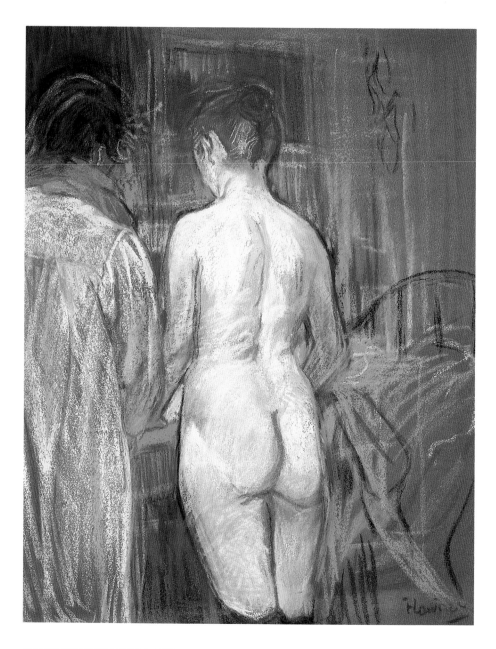

HENRI DE TOULOUSE-LAUTREC
Prostitutes, 1893–1895
Pastel on sandpaper; 24 × 19⅝ in. (61 × 49.9 cm)
Signed, lower right: *T-Lautrec*
1985.R.75

PROSTITUTES is among Toulouse-Lautrec's finest and boldest pastels. Like most of his oeuvre in 1893–1895, its imagery is drawn from the brothels in which the painter felt comfortable, and which he used as a metaphor for the human condition. Only in houses of prostitution was nudity a "natural" condition of being; only in brothels was there a "family" atmosphere among nonrelated people, and a forced honesty regarding the moral ambiguities of modern life.

The Reves pastel represents a nude prostitute seen from the back, her only apparel black knee-high stockings. The artist gives us few clues as to her activity —we see neither her face nor her hands. She is joined by a companion wearing a full-length dressing gown, who leans forward as if to speak. The setting is a bedroom with a large unmade bed. Toulouse-Lautrec does not encourage us to think of ourselves as either customers or inhabitants of the brothel, and he takes pains to separate us from the very encounter that we witness. This effect of moral and physical distancing is rare in his oeuvre and gives the work a starkness and modernity that are at odds with the emotional humanism seen in his other drawings and paintings of brothels.

The most original and extraordinary aspect of this pastel, however, is not its distancing devices but, rather, its medium. Instead of drawing the back of this beautiful young woman on a carefully chosen sheet of paper, Toulouse-Lautrec purchased a large sheet of emery board, or sandpaper, the very roughness and crudity of which are at odds with the softness and beauty of his subject. The contrast between sandpaper and the smooth skin of the artist's principal subject is remarkable. At a distance from this brilliant pastel, the roughness disappears: the sandpaper in effect softens the pastel marks, further crumbling the already crumbly medium. In fact, Toulouse-Lautrec could *only* achieve these soft effects of line by using as rough a material as sandpaper. He clearly made this sublime pastel as a technical experiment, and perhaps for that reason he chose to represent a scene that has so little psychological depth. As viewers, we will never know what is in the hearts or minds of these women, whose conversation we will never hear, and whose struggles we can only imagine.

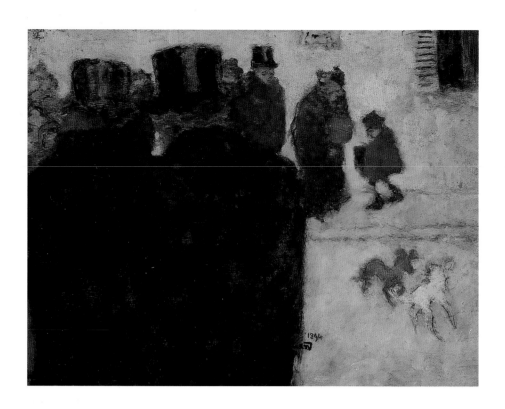

PIERRE BONNARD

Street in Winter, 1894
Oil on panel; 10½ × 13¾ in. (27 × 35 cm)
Signed and dated, lower center: *1894/bonnard*
1985.R.5

THERE IS NO pictorial connoisseur of Paris streets more delicate and humorous than Pierre Bonnard. In the early 1890s, Bonnard began a series of small paintings (exhibited at Durand-Ruel's gallery in 1897) in which he transcribed human—and canine—"moments" that he observed in Paris. For Bonnard, the accidental encounter between a tiny schoolboy lugging his satchel and an old woman with her hands buried in a fur muff caused such intense delight that he transcribed it—either from memory or through the medium of a pencil sketch—onto this small panel. Bonnard analyzes every subtle aspect of the encounter as he contrasts the monolithic shape of the woman with the boy's cantilevered coat, supported by toothpick legs stuffed into oversized boots. The river of creamy-beige paint that runs between them allows their contours to interlock without touching, and Bonnard compares this meeting to the public confrontation of two poodles (a male and a female, no doubt). To whom, we ask, do these dogs belong? Surely one is the beloved property of the old woman, while the other must have escaped from the bourgeois couple directly behind her. Soon, we know, this encounter of dogs will provoke an unplanned—and utterly urban—encounter of humans, which will occur after the little boy disappears from the field of vision.

This delightful narrative is given an ominous twist by the juxtaposition of these figures with the two couples in the foreground. We are initially tantalized by the middle-ground figures and dismiss the two bourgeois men, whose backs fill nearly half of the panel, as simply *repoussoir* figures, or compositional devices to draw us into the picture. Yet, when we look more carefully, we see that these two men stand before a pair of "painted" women, whose faces indicate that their bodies are for sale. Thus, the transaction on the left of Bonnard's picture is dominated by darkness, while the freer, more natural, and seemingly innocent interactions on the right occur in the full light of day.

This brilliantly conceived social cityscape is among the tiny masterpieces of Bonnard's Nabi years, and its quality was recognized by the single greatest collector of Nabi art, the Polish émigré writer and entrepreneur Thadée Natanson, editor of *La Revue blanche.* When Natanson sold most of his possessions in 1908, this panel was snapped up by the important dealer and critic Félix Fénéon. Few small panels by Bonnard have had a more distinguished provenance.

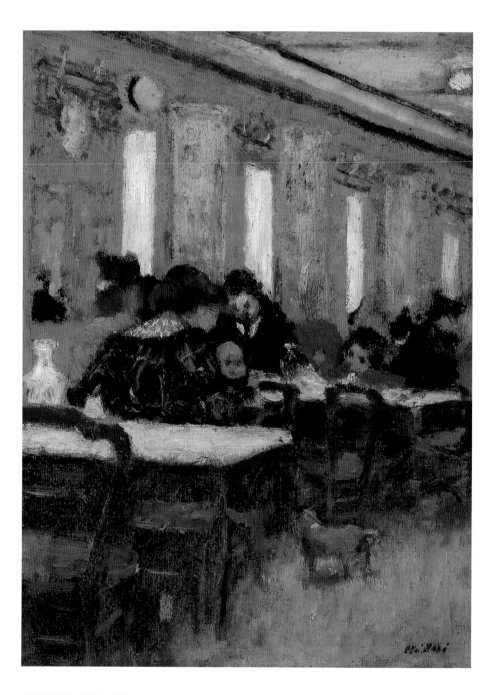

EDOUARD VUILLARD

The Little Restaurant, 1894
Oil on board; 12½ × 9⅞ in. (31.8 × 25.1 cm)
Signed, lower right: *Vuillard*
1985.R.85

EDOUARD VUILLARD was the master of Parisian observation. The decade of his greatest accomplishments was the 1890s, when this small painting was made. Vuillard's paintings at that time were either very large decorations, commissioned to fit into domestic environments, or tiny cardboard concoctions whose modesty of scale was matched by a modesty of subject. In most cases, Vuillard preferred to represent the interiors of petit-bourgeois Paris, and his small rooms, stuffed with furniture and papered with wonderful patterns, have joined the canon of modern art.

This delightful cardboard painting is something of an exception in Vuillard's production of the 1890s in that it represents a public rather than a private place. Nevertheless, it remains a supreme example of interior genre, focusing not on a public moment but on a quiet domestic scene that Vuillard observed in a restaurant. Vuillard "sets" the painting's space so that we imagine ourselves entering the little restaurant, and, rather than greeting us with the jaded habitués so common in paintings of such places by Degas and Toulouse-Lautrec, he presents us with a young family out for a meal together.

Because light floods in from the large windows, we are to imagine that the scene occurs on a Sunday afternoon, when both mother and father are at leisure and the family has time for the luxury of a restaurant meal. Vuillard pays close attention to the relationship between the mother and her baby, to the curiosity of the little girl, who leans her arms on the table, and to the family dog, who waits in anticipation for the baby to drop some food. The entire scene is delightfully sentimental and charming, and refuses to allow us one wicked thought.

Vuillard was twenty-six years old when he painted this work. He still lived with his mother, as he did throughout her life, and consorted with a convivial group of supportive vanguard artists, writers, and musicians who formed a circle around the Natanson family and their journal, *La Revue blanche*. Always childless, Vuillard was a doting uncle to his one niece and frequently painted children. Indeed, if Vuillard had a signature figure in his paintings of the 1890s, it was a little girl, and this one, with her dark black eyes and mop of unruly hair, is among his most charming.

CAMILLE PISSARRO
Bather with Geese, 1895
Pen, ink, and lead white gouache on paper;
4¾ × 5½ in. (12.1 × 14 cm)
Not signed or dated
1985.R.43

THESE CURIOUS DRAWINGS belong to a set of at least eight sheets made by Camille Pissarro early in 1895 as part of a collaborative project with his son. Lucien Pissarro, who lived in England, was extensively involved in the woodcut and wood-engraving revival that began in England in the 1850s. Initiated by William Morris, the movement gathered converts steadily, reaching an apex at the end of the century with a group of young artists that included Lucien Pissarro. The aim of this revival was to inject a new vitality into the art of the hand-printed book. Illustrations were created in harmony with newly designed type-faces to produce a completely integrated work of art.

Camille Pissarro had been a prac-ticed and successful printmaker for more than a generation when Lucien embarked on his mission, and in order to encour-age his son and to learn a new technique, the elder Pissarro agreed to collaborate on a number of projects. The most im-portant of these was to have been called *The Work of the Fields,* for which Lucien later commissioned an evocative text from Benjamin Guinaudeau. Camille Pissarro was to make the drawings, there-by lending his famous name to the work, while Lucien would be in charge of mak-ing the prints and producing the book. Ultimately, the project was a fascinating failure, producing many drawings, most of which remain in the Ashmolean Mu-seum at Oxford University, but never a finished book. The work had three dis-tinct phases, the first of which resulted in a portfolio of color and monochrome prints produced in 1891–1894 and re-leased in 1894. The second, to which these drawings belong, commenced and ended in 1895, and seems not to have

The Harvest (La Moisson), 1895
Pen, ink, and lead white gouache on paper;
4 ¹¹/₁₆ × 5¼ in. (11.9 × 13.6 cm)
Initialed, lower right: *C. P.*
1985.R.47

progressed very far. The third and final stage involved the commissioning of the text and numerous illustrations, but it, too, foundered.

Neither of the Reves drawings has been published before, and they add considerably to our knowledge about the second phase of *The Work of the Fields.* Although they relate technically to a number of sheets in the Ashmolean, both are more highly finished and exhibit numerous changes and alterations. Both appear to have been drawn by Camille Pissarro, who sent them to Lucien for "translation." They were either rejected or criticized and returned to Camille, who carefully cut out and glued on additional pieces of paper. He then "corrected" the drawings, possibly to balance the darks and lights so as to ensure that the sheets would harmonize with printed type. The elder Pissarro must have been

pleased with these sheets because they were apparently separated from the other drawings and sold during his lifetime.

There are no drawings directly related to the *Bather with Geese,* which shares imagery, but not exact poses and compositions, with two prints, an etching of 1895 and a lithograph of 1895–1896 (Delteil 1923, nos. 115 and 161). The harvest scene is another matter. It appears to have been based on a lithograph of 1894 that includes identical figures but has a more spacious landscape setting. The drawing could also have been based on a sheet in the Ashmolean Museum (Brettell 1980, 341) that appears to be a tracing from the 1894 lithograph.

CAMILLE PISSARRO
Bathers, 1895–1896
Watercolor monoprint with pencil and gouache
on laid paper; 7¼ × 9¼ in. (18.4 × 23.5 cm)
Initialed in brown ink, lower left: *C. P.*
1985.R.46

IN THE SPRING OF 1895, an exhibition of paintings by Paul Cézanne opened in Paris at Ambroise Vollard's gallery. It was the first major showing of the reclusive painter's work since 1877, when he exhibited with the impressionists. There is little doubt that the Cézanne exhibition was the single most important artistic event of the year. Pissarro, who had painted with Cézanne throughout the 1870s and early 1880s, was particularly moved by the exhibition, and in direct response, he began a series of compositions depicting bathers. This previously unpublished monotype is among the most powerful of a small group of monoprints of bathers made in 1895–1896. Unlike many others, the Reves monoprint relates directly to a painting, also entitled *Bathers,* of almost identical dimensions (1896, private collection; Pissarro 1989, no. 941). In making the monoprint, Pissarro not only reflected on the achievement of his friend Cézanne but also paid aesthetic homage to Edgar Degas, whose monotypes of brothels of the late 1870s and early 1880s Pissarro knew. Thus, this work plays a complex role in the history of French vanguard art.

Pissarro had used the monoprint technique since the late 1870s or early 1880s. His contribution to the medium was considerable, and his monoprints, together with those of Degas and Gauguin, form the core of French printed drawings of the late 19th century. The technique itself is actually a conundrum, combining the directness of drawing with the indirectness of printing. The paradox is that in printing the drawn plate one destroys the drawing and produces an absolutely unique print. Thus, the most obvious advantage of printmaking —producing many nearly identical versions of an original—is negated. Pissarro reveled in this situation, creating printed works that have the vivacity and immediacy of drawings. In fact, the Reves monoprint has most often been exhibited as a watercolor. Like all perfectionists, Pissarro could not refrain from touching up the print with direct applications of pencil and gouache, ensuring that this confusion between print and drawing would persist.

EDGAR DEGAS

The Bathers, 1895–1897
Pastel and charcoal on tracing paper mounted
on gray board; 42¹⁵⁄₁₆ × 43¾ in. (109 × 111 cm)
Studio stamp, lower left: *Degas*
1985.R.24

EDGAR DEGAS CREATED this monumental bather composition in the mid-1890s, probably after he had seen the great Cézanne exhibition held at Vollard's gallery in the spring of 1895. Cézanne's work was perhaps the impetus for Degas to move his bathers out-of-doors and away from the urban brothels, boudoirs, and bathrooms that he had favored. It may also have been Cézanne's example that pushed Degas to create these bathers on such a large scale. The Reves pastel is of identical dimension to another outdoor bather scene, now in the Art Institute of Chicago (see fig.), and it is possible that the two works were conceived as pendants. However, they were neither completed nor exhibited as such during the painter's lifetime, and both were included in the huge auctions held in Paris after the painter's death.

The principal oddities of the Reves pastel are the two figures on the right. When one compares the sheet with an even larger charcoal drawing with the same figures that was also included in the Degas sales (Lemoisne 1946, vol. 3, no. 1070), it becomes clear that Degas cropped both these figures from the Reves sheet so as to concentrate the composition on the bather combing her hair. It is likely that the Reves sheet was traced from the original charcoal version onto a very large sheet of tracing paper, which was probably chosen to match the dimensions of the Chicago painting.

Edgar Degas, *The Bathers*, 1895–1905. Pastel and charcoal on tracing paper, pieced and mounted on board, 44⅝ × 45½ in. (113.4 × 115.7 cm). The Art Institute of Chicago, Gift of Nathan Cummings.

These immense bathers have an undeniable physicality. Even the hair of the central figure seems to have weight as it flows over her head across the front of her body. Degas's inclusion of a cow in a nearby field can be read in two ways—as a pictorial indicator of the rusticity of the subject or as an unsubtle analogy between woman and barnyard beast. In spite of Degas's well-known misogynist tendencies, the latter reading seems farfetched, and the more likely interpretation of this scene, and of other outdoor nudes by Degas, is that it was intended to be a rural counter to the bathers in interior settings for which the artist was already famous. Few pastels from Degas's late career are as magisterial, ambitious, and powerful as the Reves *Bathers*.

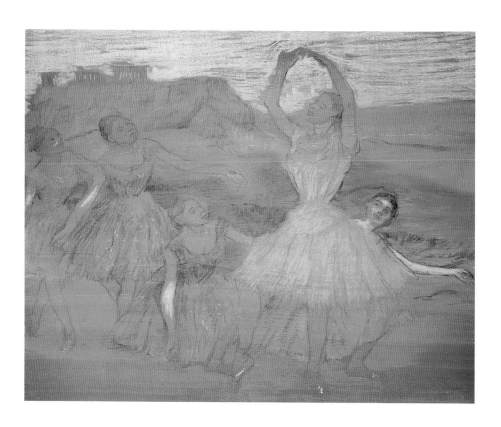

EDGAR DEGAS

Group of Dancers, 1895–1897
Pastel and gouache on panel;
12½ × 16 in. (31.7 × 40.6 cm)
Signed, lower right: *Degas*
1985.R.25

THIS ENIGMATIC DRAWING on panel has never before been published. The stamps and numbers on the verso indicate that it was sold by the great French dealer Paul Durand-Ruel during Degas's lifetime. But because the drawing's early provenance is not known, and because of the odd materials and somewhat awkward manner of drawing, its authenticity has occasionally been doubted. However, the exhibition labels and the panel's clear relationship to well-catalogued works make its attribution to Degas a certainty.

Degas was fascinated throughout the mid-1890s with scenes of dancers out-of-doors, and his famous sequence of so-called Russian dancers with Slavic costumes (Lemoisne 1946, vol. 3, nos. 1181–94) has long been admired by connoisseurs and critics. Less well studied are three "civilized" counterparts to the "peasant" dancers. The Reves panel, which was unknown to Lemoisne, is an elaboration of a pastel, also called *Group of Dancers,* that was owned by Degas's brother René de Gas and included in his posthumous sale of 1927. This René de Gas sheet includes four of the five figures of the Reves panel in identical positions, and places this group in the same classical landscape with a distant background of the Acropolis in Athens. We know that Degas never visited Greece, and clearly we are to believe that the setting for these dancers is a painted backdrop. In fact, their costumes and the white arm of the dancer on the far right disguise what must be the lower edge of the backdrop where it meets the floor of the stage. By employing this device, Degas created the illusion that the dancers are actually *in* the landscape.

The background relates without question to the landscape monotypes that Degas made in the years around 1890, as well as to the numerous out-of-door genre scenes of the mid- and late 1880s. In these late works, Degas asserted the sheer artificiality of his art, which was a quintessentially urban art form, by evoking various imaginary landscapes from his Parisian studio. Here, in the Reves panel, we travel through Degas's imagination to the distant setting of Athens. The painter was careful to let us know that the Athens of his drawing was not the classical-era city, since the Parthenon and its attendant buildings are in ruins; nor is it modern Athens, whose buildings encircle the Acropolis. Instead, it is a dream or memory—a visual evocation—of the great ancient city, enlivened by the classical poses of Degas's beloved dancers.

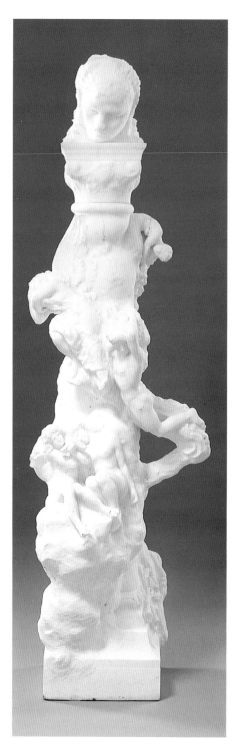

AUGUSTE RODIN

The Poet and the Contemplative Life, 1896
Marble; H. 72¼ in. (184 cm), W. 20½ in.
(52.1 cm), D. 23¾ in. (60.3 cm)
Signed, on base at right: *A. Rodin*
1985.R.64

RODIN ASPIRED TO BE, and almost succeeded in becoming, the Michelangelo of modern sculpture. No single figure in the 19th century can match the sheer range, ambition, and scale of his achievement, and no true history of European sculpture could omit him. Almost as if to challenge Baudelaire's famous essay "Why Sculpture Is Boring," written for his review of the 1846 Salon (Baudelaire 1961, 943–45), Rodin reinvigorated figural sculpture just as the impressionists were giving new life to the pictorial arts in France. Nevertheless, because of the traditionalism and craft-based production of sculpture, Rodin's art has more (and more obvious) debts to Renaissance and baroque art than does the painting of the impressionists and their followers.

Throughout his long life, Rodin produced work for the official Salon, and the Reves marble, the most important work by Rodin in a public collection in Texas, is among the most enigmatic of these works. *The Poet and the Contemplative Life* was commissioned from Rodin by Maurice Fenaille and was completed in 1896. It was included both in the Salon of 1897 and in the major Rodin exhibition held on the place d'Alma during the 1900 Paris World's Fair. Like the model for *Monument to Labor* (Musée Rodin, Meudon), the *Gates of Hell* (Musée Rodin, Paris), and the monumental sculptural groups dedicated to Claude Lorrain and Victor Hugo, the Reves marble combines a large number of human figures with allegorical elements, all of which seem to spring from architecture. This fusion of sculpture and architecture characterized Rodin's late career and has been linked to contemporary currents in European symbolism. In fact, the roots of Rodin's fantasies go back further to baroque sculpture.

Who is the poet whose mournful disembodied head rests atop the chaste capital on this riotous figural column? In all probability, the head is a symbol of "poetry" rather than a representation of a particular poet, although many of Rodin's contemporaries must have associated the work's appearance in 1897 with the death of Stéphane Mallarmé in 1896. The head is reminiscent of an earlier Rodin marble, entitled *Thought* (Musée Rodin, Paris), which was modeled on the well-known features of Camille Claudel, Rodin's model, mistress, student, colleague, and assistant. If the head signifies "poetry" as an intellectual or cerebral, rather than sensual, activity, Rodin contrasts this idea with the riot of human figures, symbols, passions, and allegorical forms that crowd together in the column below. In his insistence on separating the "body" of the column from the "head" by means of a stylized capital, Rodin suggests that poetry resides in the head itself, not in the body on which it rests, as a sculpture rests on a base.

The emblem of the disembodied head had been exploited in similar "literary" contexts by Odilon Redon, and Rodin's melancholic head has many affinities with the pictorial prototypes produced by the younger artist.

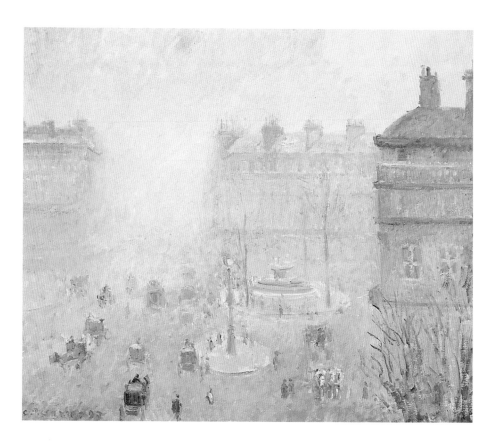

CAMILLE PISSARRO

Place du Théâtre Français: Fog Effect, 1897
Oil on canvas; 21⅜ × 26 in. (54 × 65 cm)
Signed and dated, lower left: *C. Pissarro 97*
1985.R.50

CAMILLE PISSARRO PAINTED fifteen cityscapes of Paris viewed from his suite at the Hôtel du Louvre in the winter of 1897–1898. Four, including *Place du Théâtre Français: Fog Effect,* were done on "size 15" canvases, the smallest of the three sizes he used for the series (Pissarro 1989, no. 1019). Unlike Monet, whose series of grain stacks, poplars, and cathedrals were made in identical formats, Pissarro preferred to vary the scale and point of view in his series so that each work was unique. Then, in working with his friend the dealer Paul Durand-Ruel, Pissarro arranged the paintings in harmonious groupings on the walls, creating pairs, trios, and quartets of canvases. This painting must have been made as a pair with *Avenue de l'Opéra: Snow Effect* (1898, Musée Saint-Denis, Reims), which is of identical dimensions and is also devoted to an effect of weather. When Pissarro exhibited twelve paintings from the series in the gallery of Durand-Ruel in June 1898, the Reves painting was not included, although it was finished. It may have already been sold, since its first owner, Eugène Blot, was actively collecting in the late 1890s.

The Reves painting is the only fog effect of the series, and was one of only two paintings finished in December 1897, during the first of Pissarro's two campaigns devoted to the avenue de l'Opéra and its environs. This canvas is also one of four that deal with the venerated Théâtre Français building, which looms ominously on the right, its mass contrasting with the fog-filled void of the avenue de l'Opéra. Pissarro did not frequently paint fog, an effect preferred by Monet, Sisley, and Renoir. Indeed, the tangibility of form was so much a part of Pissarro's aesthetic that he avoided dealing with intangible atmosphere. Yet, this subtle painting is masterly in its evocation of the lavender wetness of a dull winter day in Paris. Pissarro's earlier study of fog on the boulevard Montmartre was included in the 1898 exhibition.

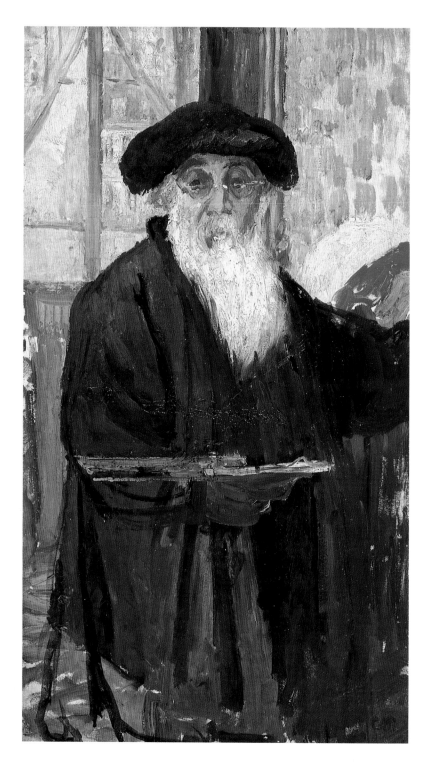

CAMILLE PISSARRO
Self-Portrait, 1897–1898
Oil on canvas; 20⅞ × 12 in. (52 × 31 cm)
Stamped, lower right: *C. P.*
1985.R.44

CAMILLE PISSARRO PAINTED only four self-portraits during his long life. The first (Musée d'Orsay, Paris) was finished, signed, and dated in 1873, a year of intense plein-air painting with Cézanne. The last (Tate Gallery, London) was finished, signed, and dated in 1903, just months before his death. The remaining two were neither signed nor dated, but were stamped with the artist's initials after his death and remained in the possession of the Pissarro family. The Reves portrait is more unusual and easier to place in time than the other undated self-portrait (c. 1898, Edwin C. Vogel Collection, New York). It was painted between December 1897 and February 1898, in Pissarro's hotel suite on the second floor of the Hôtel du Louvre, on the place du Louvre at the center of Paris. In the hotel room, Pissarro worked on his most significant series of urban paintings, representing the avenue de l'Opéra, of which one of the subtlest versions is also in the Reves Collection (p. 124).

This self-portrait was made at a time of tragedy and emotional strain for the sixty-seven-year-old painter. Earlier in the year, he had nursed his eldest son, Lucien, back to health from a stroke, and his younger son, Félix, was diagnosed with tuberculosis and died at the age of twenty-three on 25 November. Perhaps in an effort to deal with these hardships, Pissarro threw himself into his greatest series of urban paintings, creating fifteen masterpieces from the window of his room in a scant six weeks. Perhaps also to gauge his own strength and conquer the loneliness of a Paris hotel, he began this, his first painted self-portrait since 1873. As if these personal trials were not enough, Pissarro had the additional burden of living as a Jew in Paris at the height of anti-Semitism in that country.

With the publication of Emile Zola's *J'Accuse* in January 1898, the Dreyfus Affair had emerged as the overriding national issue. For many reasons, Pissarro was more consumed with the fate of Captain Alfred Dreyfus than were his colleagues. These burdens—both moral and mortal—weighed on him and were exacerbated by his persistent eye infections.

Yet, when we look at this self-portrait and remind ourselves of Pissarro's problems, the painting seems to shed them in favor of the quiet persistence of work. For Pissarro, work was "the moral regulator of life" (Mirbeau 1904, preface). When he suffered traumas, he never sought to depict them or to embody their effect on his tortured soul but, rather, attempted to approach himself honestly and simply through the act of self-representation. He set himself up in his room at the center of a triangle—the window at his back, a mirror in front of him, and the painting between them. In this simple arrangement, he conjoined the two principal metaphors for painting —the mirror into the soul and the window onto the world. And at their nexus, he placed himself as painter in the act of patient representation.

Pissarro never finished the painting, and we can measure his uncertainties and transformations as we look at it. The palette has been lowered and made strictly parallel to the bottom edge, and Pissarro adjusted his painting smock to gain control of the left side of the painting. Perhaps he abandoned the self-portrait in his haste to finish the series of cityscapes for exhibition at Durand-Ruel's gallery in June of the same year. In the end, Pissarro's views from the window were, for him, a more enduring indicator of his ideas than any self-portrait.

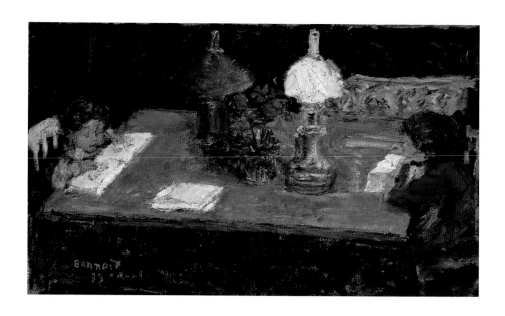

PIERRE BONNARD
The Terrasse Children, 1899
Oil on canvas; 11½ × 20¼ in. (29 × 51 cm)
Signed and dated, lower left: *Bonnard 99*
1985.R.4

AMONG PIERRE BONNARD'S greatest supporters were his sister and brother-in-law, Claude and Andrée Terrasse, whom he painted throughout his life and to whom he entrusted his estate. Perhaps because the painter and his common-law wife, Marthe, remained childless, they became surrogate parents to the Terrasse children. Most of the many children in Bonnard's paintings are his nieces and nephews. Often, as in the Reves painting, the children inhabit the rooms and gardens of the family properties, their bodies and faces merging with the textures of their environment. Here, Bonnard finds Charles (left) and Jean (right) as they read at night, probably after dinner and before bed. Our viewpoint is that of an adult looking down on them, but they seem utterly oblivious to our presence. The elder, Jean, has looked up from a thick book and seems to be listening to his younger brother as he reads from a children's book. The dialogue of the two young boys has a counterpart in the "dialogue" of two lamps on the ample table. With its omniscient painter/observer and its immersion into a private space, the painting is quintessentially intimist.

Reading as a subject in Western art has a long and complex history, which was enlivened considerably by vanguard French artists such as Manet and Degas. But no French artist since Chardin was as fascinated with the education of the young as Bonnard proved himself to be in this wonderfully subtle canvas.

When Emery Reves first acquired the painting in the mid-1950s, he wrote to Charles Terrasse, who then controlled the Bonnard estate. Terrasse identified both figures and told Reves that it was painted on a summer weekend in 1899 in the family's country house in Grand-Temps in the Dauphiné.

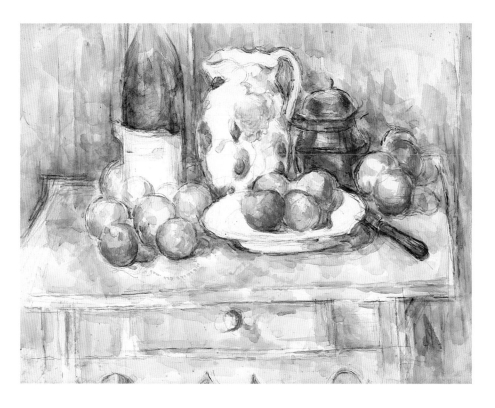

PAUL CEZANNE
Still Life with Apples on a Sideboard, 1900–1906
Watercolor on paper; 19⅛ × 24⅞ in. (48.5 × 63.2 cm)
Not signed or dated
1985.R.12

THE WATERCOLOR MEDIUM arrived rather late in France. After a glowing history in British 18th- and early 19th-century art, it crossed the Channel in the work of a bilingual English artist, Richard Bonington, and his friends the French artists Théodore Géricault and Eugène Delacroix. Although the two French artists made distinguished contributions to the medium, watercolor did not in fact become central to French painting until the 1870s, when the impressionists practiced it fervently.

The Reves Collection is particularly rich in watercolors, but its crown jewel in the medium is this great Cézanne still life. Although one could have a full and complete discussion of the careers of Manet, Monet, Pissarro, Seurat, and Gauguin without ever mentioning watercolor, it would be impossible to do so for Cézanne. The watercolor medium was central to his technique as an artist, and as his career progressed, his oil technique increasingly resembled that of his watercolors. Indeed, his reliance on the primed canvas as a positive element in his late oil paintings would have been inconceivable without a knowledge of watercolor technique.

This late watercolor is among the very finest of Cézanne's career. Along with a small group of equally large and complex sheets scattered in major collections in the United States, Switzerland, France, and Britain, this watercolor is the apogee of his art.

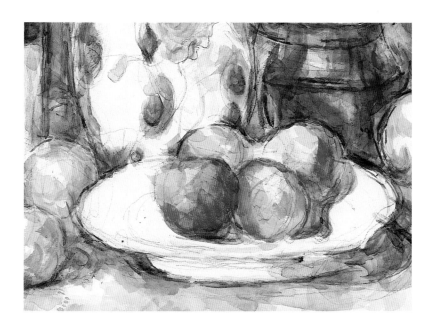

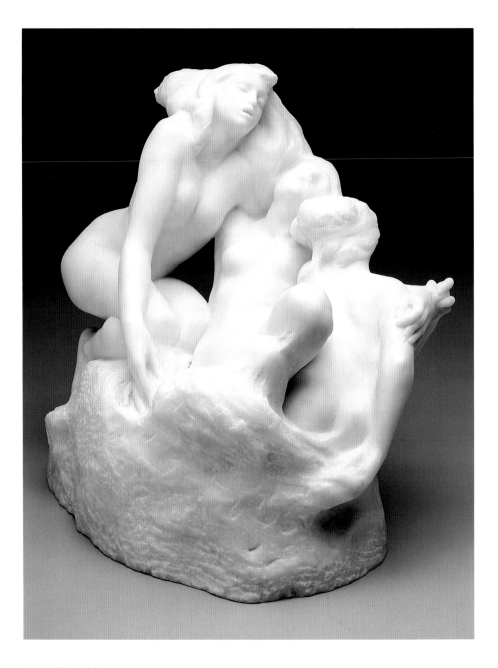

AUGUSTE RODIN

The Sirens, c. 1900
Marble; H. 17 in. (43.2 cm), W. 17¾ in.
(45.1 cm), D. 13 in. (33 cm)
Signed on back, at left: *A Rodin*
1985.R.65

RODIN'S SIRENS LURE US today with their undulating bodies and mute songs. In linking desire with death they tell us more about the psychosexual anxieties of the fin de siècle than they do about classical mythology. The group of three women was featured in miniature in Rodin's *Gates of Hell*, where they appear on the left side of the left panel as it was reconfigured in the 1890s. When Rodin first conceived them in 1888, he worked to create a definitive plaster, which was used as the basis for a large number of bronze casts and studio marble versions. He then miniaturized them and placed them in his aesthetic prison, *The Gates of Hell*.

The Sirens was first exhibited as *Niobe* before becoming *The Three Sirens* in 1900. In the catalogue for that year's immense Rodin exhibition, they were related to a more recent love-death concoction, the Rhine maidens of Richard Wagner's operas. The sheer beauty of the group and their comparative simplicity of meaning must have appealed to many collectors of Rodin's work. At least five marble versions survive, all created by studio assistants in Rodin's immense and utterly professional atelier. In addition to the version in the Reves Collection, other marble translations with various bases can be found at the Musée des Beaux Arts, Montreal; the Ny Carlsberg Glyptotek, Copenhagen; and the Thielska Gallery, Stockholm. All were carved from similar milky-white crystalline marble, which was superbly polished to encourage the viewer's tactile desires.

THEO VAN RYSSELBERGHE

Portrait of Mme Monoum, 1908
Pencil on laid paper; 14½ × 9¾ in. (36.8 × 24.8 cm)
Dated and initialed, at right: *20 Janv. 08*
above *VR* (conjoined) in a square
1990.R.179

THEO VAN RYSSELBERGHE was one of the most fervent of the artists who gathered around Camille Pissarro and Georges Seurat to revolutionize painting. Incorrectly believing that impressionism was a fundamentally romantic and emotional art, they attempted to insert into painting the rational principles of color, light, and psychological theory derived from the sciences and, thus, to become what they called "neo-impressionists."

Van Rysselberghe's paintings of the years around 1890 are canonical examples of this limited and short-lived idea of art. Less well known, but perhaps more expressive, are his remarkable pencil drawings, many of which are based on his study of Cézanne's drawings. This superb portrait of a dominating, extraordinary sitter is among the strongest of these efforts. We long to know more about Mme Monoum.

MAURICE DE VLAMINCK

Bougival, 1905–1906
Oil on canvas; 32½ × 39⅝ in. (82.5 × 100 cm)
Signed, lower left: *Vlaminck*
1985.R.82

THE PINNACLE of Maurice de Vlaminck's career occurred in 1905–1906, when he painted in the villages of Châtou and Bougival just west of Paris. Of the two dozen best paintings he made during this intensely active period, the Reves *Bougival* is probably the finest. Its large scale, complete compositional control, and confident mastery of touch make it a self-conscious masterpiece in which Vlaminck attempted to reconcile in one canvas the seemingly contradictory landscape traditions of Paul Cézanne and Vincent van Gogh.

For his vantage point, Vlaminck climbed the steep hill just south of the village of Bougival and turned his easel almost directly westward to face the village and the distant valley of the Seine. The season is difficult to ascertain because the foliage is brilliant green in the middle ground and vibrant yellow in the foreground. There had been a major van Gogh retrospective in 1904, which Vlaminck must have studied with real interest, and it is no accident that the

motif of the red field with a recently planted orchard has many analogies in the painting of van Gogh, particularly of 1888–1889. Yet, for all the frantic pictorial gestures, for all the thick, viscous paint and the brilliant hues, this painting has a balanced, classically conceived composition and a highly schematic palette of primary colors that tame the apparent wildness of Vlaminck's touch. This picture alone illustrates why Vlaminck realized, when he saw the important Cézanne retrospective in 1907, that his true vocation was as a painter in the French classical tradition.

The early exhibition history of this canvas is not known. Its generic title makes it difficult to identify as one of the paintings exhibited in any of the early fauve exhibitions, but its scale and ambition suggest that it might well have been included. How easily we can imagine it in a room with great fauve paintings by Henri Matisse and André Derain, and how strong it would have looked in that august company.

EDOUARD VUILLARD
The Tent, 1908
Distemper on paper mounted on canvas;
29½ × 44½ in. (73.4 × 110.4 cm)
Signed, lower right: *E. Vuillard*
1985.R.83

EDOUARD VUILLARD traveled by train to the Brittany resort town of Penchâteau in July 1908 to visit his friends Joseph and Lucie Hessel, who had rented a house there called Ker Panurge for much of the summer. Joseph Hessel was a partner in the large art gallery Bernheim-Jeune, which handled Vuillard's work as well as that of his friend Pierre Bonnard. While in Brittany with the Hessel family, Vuillard was inspired to make a large number of works, among the most important of which is *The Tent,* which he referred to in his journal entry on 29 July as "a sketch in tempera, the tent." He had traveled to Brittany with Alfred Natanson, who, with his brother Thadée, founded *La Revue blanche,* Alfred's wife, the actress Marthe Mellot, and

their two daughters. Later in the month, the painter Bonnard, his common-law wife, Marthe, and Vuillard's mother arrived to complete the house party. During their residence in the large house, many others came for luncheons, dinners, and long leisurely afternoons, and Vuillard represented these occasions almost as if he were a court painter for the Jewish intelligentsia.

Photographs probably dating from 28 July 1908 by both Vuillard (who was a gifted and passionate photographer) and Alfred Natanson document an afternoon visit to Ker Panurge by other friends, including the writers Romain Coolus and Tristan Bernard, and Bernard's wife, Marcelle Aron. Many of these photographs are sited in and around a striped

garden tent set up to protect the weekend party from the wind and sun of the Brittany coast. Vuillard made many sketches of this afternoon, two of which are preserved in the Reves Collection.

Many friends of Vuillard recall that he was an obsessive draftsman, that he was virtually always present with a small sketchpad and pencil, and that he made thousands of sketches throughout his life. Many of these survive, and most of the ones from the early years of the 20th century are closely related to these sheets in technique and purpose. The artist drew sheets of this sort, called *croquis* in French, with a burst of energy while staring fixedly at his motif. The aim of the *croquis* was not to look at the drawing, but to create, using a few simple gestures, an instant diagram of a particular scene that might become the scaffolding for a subsequent work of art. As such, *croquis* can be preparatory, and they constitute an intensive form of visual research. Vuillard himself probably employed them in concert with his photographs as an aide-mémoire when constructing his larger works.

Vuillard's own description of *The Tent* as a "sketch" *(pochade)* links it to impressionist practice. Monet used the same word in describing his sketches of the waterside cafe La Grenouillère in 1869. Vuillard, like Monet, wanted his work to convey the immediacy experienced at the site—in this case, a windy coastal garden in Brittany—and so it does. *The Tent* is alive with gesture, as is a slightly smaller and differently constructed work called *La Tente rayée* (1908, private collection, Geneva). Our eyes pass rapidly across the surface,

Two studies for *The Tent,* 1908. Pencil on laid paper, 3⅜ × 5⅝ in. (8.6 × 14.3 cm) each. Estate stamps, lower right: *E. V.* Dallas Museum of Art, The Wendy and Emery Reves Collection, 1985.R.84.

alighting at a figure or a part of the tent, but never for very long. Like the impressionists, Vuillard was interested in entrapping the entire visual field. As we look at his "sketch," we feel precisely the sensation of a blustery, windswept afternoon when we attempt a conversation, perhaps after having a little too much wine at lunch. The discreet pleasures of bourgeois life have seldom had a better visual archivist than Vuillard.

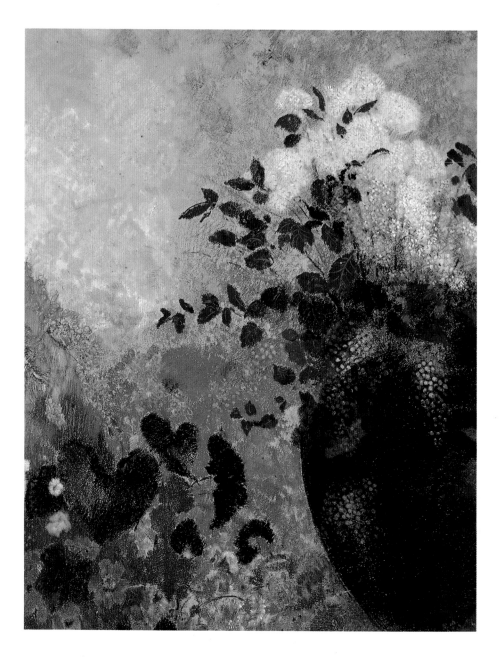

ODILON REDON

Flowers in a Black Vase, 1909–1910
Pastel on paper mounted on cardboard;
34⅜ × 27 in. (87.3 × 68.5 cm)
Signed, lower right: *ODLON [sic] REDON*
1985.R.55

JORIS-KARL HUYSMANS, the great symbolist novelist and critic, called Odilon Redon "the prince of dreams" in an essay of 1885 (Huysmans 1885, 291–96), and he devoted many feverish pages to his friend's tenebrist "dream drawings" of the late 1870s and early 1880s in his cult novel, *A rebours*. Indeed, Redon's early charcoal and black chalk drawings and his lithographs, which he collectively called his *noirs* (blacks), do little to prepare us for his conversion to color in the 1890s. Over the course of that decade, he began to drain literary and associative content from his work and to employ the interaction of color to produce a mysterious emotional resonance that he believed was more universal than what he achieved in his earlier *noirs*. Increasingly, his work was filled with flowers, butterflies, leaves, and gently vibrating patterns with no clear relationship to the visual world.

Redon's most commercially successful works in color were his commissioned portraits and large series of floral still lifes, of which the Reves *Flowers in a Black Vase* is among the very finest. Rather than center the vase of flowers, as was conventional both in the genre and in Redon's particular practice of it, he positioned this large black vase on the very edge of the composition and allowed a profusion of yellow, white, and blue flowers to spill out of it, across a palpitating visual field of creamy beiges, pale grays, luminous whites, deep slate blues, and earthy greens. There are as many flowers and leaves outside the black vase as in it, suggesting that this particular arrangement of flowers is in an imaginary garden where others grow in abundance.

Redon employs all his skill to make us accept this floral still life as a work of the imagination rather than a representation of an actual vase of flowers in an actual place. The vase itself dissolves at the base, separating into its two artistic components—contours (black lines) and color (a deep, almost black blood-red)—refusing, thereby, to be read in conventional illusionistic terms. And Redon goes to greater pains to make sure that we cannot find any surface on which the vase can rest. Instead, we are returned again and again to the surface of the pastel itself, which becomes the true subject of the work.

There was a striking increase in the number of major painters who produced floral still lifes in the second half of the 19th century in contrast to the first half. One can scarcely imagine David or Ingres "stooping" to such depths, and even Delacroix, the greatest sensualist of 19th-century French painting, made only a handful of floral still lifes. Yet, in the second half of the century, virtually every great painter worked in the genre, and some—Courbet, Manet, Renoir, Monet, Cézanne, and Gauguin—made important contributions to it. Why? The answer lies both in the increase in the horticultural industry—which brought more people into direct contact with a greater variety of blooming plants—and in the artists' sense that they could gain access to nature's "palette" through the medium of flowers. Redon, like his contemporary Gauguin, was fascinated not only by the colors of flowers but by their scents, and imagined that in making a floral still life such as *Black Vase* he brought all the senses into harmony.

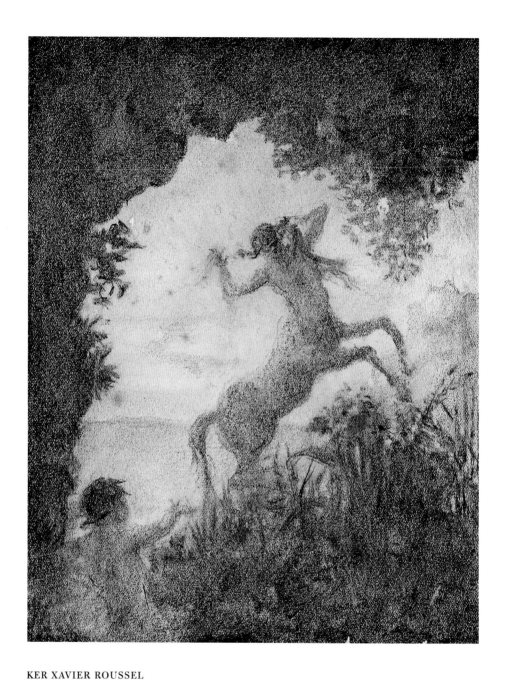

KER XAVIER ROUSSEL
The Female Centaur, 1933–1935
Lithographic crayon on wove paper;
8⅛ × 6¼ in. (20.6 × 15.9 cm)
1990.R.178

KER XAVIER ROUSSEL was one of the most important painters of the Nabi circle. But history has not been kind to him, and today his works remain little known and mostly unpublished. A friend, collaborator, and brother-in-law of Edouard Vuillard, he lived on an inherited income and produced works for both the art market and private clients throughout his long life. After flirting with modernism as a member of the Nabi brotherhood during the 1890s, Roussel became increasingly conservative and antimodernist, particularly in his imagery, and spent much of his life painting classical and mythological themes as exquisite decorations.

During the 1930s, Roussel created a brilliant group of lithographs devoted to the life of centaurs. In them, we see families of centaurs, herds of male and female centaurs, and individual centaurs of both sexes frolicking in nature. All of these prints are small, and they were apparently made without a clear relationship to a particular text, either classical or modern. If this is so—and Roussel's lifelong practice indicates that it is—the lack of a clear literary analogue suggests that Roussel's "mythologies" are not academic. Rather, he intended to revivify the drama of ancient mythology through the pictorial arts in a thoroughly contemporary manner.

The Reves sheet is a recent acquisition to the collection. It does not relate precisely to any of the lithographs produced in editions by Roussel.

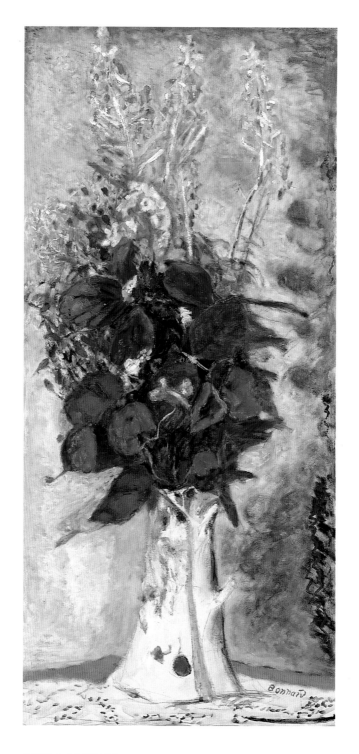

PIERRE BONNARD

Pitcher with Flowers, c. 1935
Oil on canvas; 37 × 17½ in. (99 × 44 cm)
Signed, lower right: *Bonnard*
1985.R.3

BONNARD WAS in his mid-forties when he began to paint floral still lifes, but after 1910 he contributed several canvases annually to that tradition of painting. The Reves *Pitcher with Flowers* was purchased from Bonnard by the dealers Bernheim-Jeune in 1935, but there is no other evidence that it was painted in that year. Bonnard had painted similar floral still lifes showing the same pitcher since 1911, creating more than fifteen comparable works. This is among the greatest of the group. It is noted as the last in the official catalogue raisonné of Bonnard's work. Yet, from stylistic evidence, the painting is closely related to the canvases of the late 1910s and early 1920s. Perhaps the only clue that it might indeed have been made in 1935 is the broken handle of the ceramic pitcher, which in the earlier still lifes had been whole.

Did Bonnard paint these exquisite but simple floral still lifes solely for money, as some might claim? The answer must be a resounding no. After World War I, Bonnard's paintings were selling well, and he had no need to produce works for the market. It seems more likely that he added this type of painting to his arsenal, working with still-life elements if the weather was too windy, too gray, or otherwise inclement, or, perhaps, if Marthe, his wife and perennial model, was napping or walking in the garden. A bunch of various leaves and flowers, casually arranged in his familiar pitcher, must have moved him one day, and he worked to capture their energy and freshness in the dappled light from a nearby window. Only the broken handle on the pitcher gives this buoyant painting a faint note of the melancholy that seems to have filled Bonnard's life.

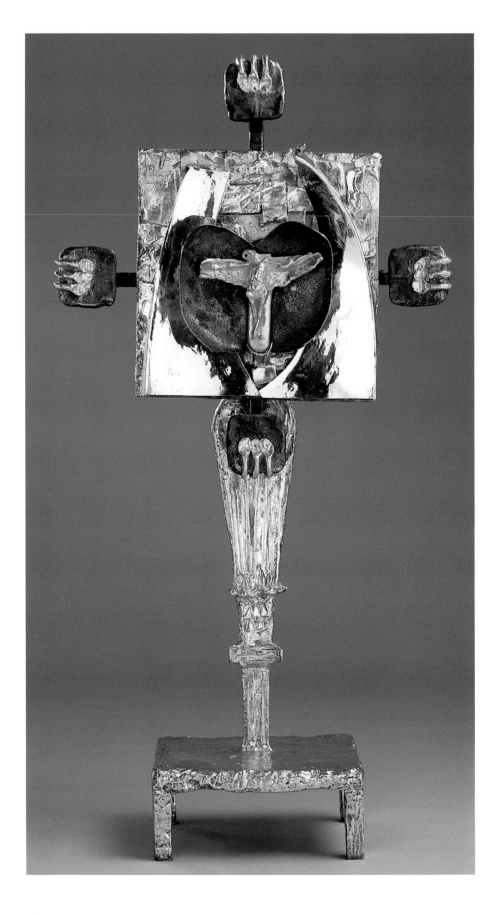

GRAHAM SUTHERLAND AND
LOUIS OSMAN
The Cross of Ely, 1964
Silver and gold; H. 43½ in. (111 cm), W. 22 in.
(55.9 cm), D. 12 in. (30.5 cm)
Not signed or dated
1985.R.71

AFTER THE DESTRUCTION that World
War II brought to Coventry Cathedral
and other important religious spaces in
England, British artists were called to
the service of the church in a develop-
ment that many thought antithetical to
the profound secularism of modern art.
By 1944, Henry Moore and Graham
Sutherland had been commissioned
to produce works for St. Matthew's Ca-
thedral in Northampton, and in 1961
Sutherland agreed to work with the ar-
chitect and goldsmith Louis Osman to
produce a cross for the high altar of Ely
Cathedral (11th–15th century), one of the
glories of English Gothic architecture.
They intended to create a visually pow-
erful object that could be seen through-
out this immense cathedral, and thereby
allow the entire congregation to experi-
ence the centrality of Christ's passion in
a space consecrated to his worship.

The task was not a simple one. The
high altar at Ely stands in front of an
extremely complex 14th-century stone
altar screen that rises more than twenty
feet above the altar and is alive with
late Gothic arches, pinnacles, figures,
and polychromed mosaic inlay. Behind
this screen is a trio of immense Gothic
stained-glass windows framed by a daz-
zling array of columns, arches, and
carved moldings. The entire ensemble
is an artistic equivalent to musical po-

lyphony that raises the viewer's emo-
tional pitch by the profusion of rhyming
forms, each more elaborate and complex
than the last. To achieve any visual rec-
ognition in this setting was a challenge to
Sutherland and Osman.

As a painter, Sutherland had never
produced a three-dimensional form for
such a demanding environment, but he
relied on his collaborator to enable him
to visualize the cross in space. They
achieved the desired effect through con-
centrated form and precious material
rather than through size; the cross stands
less than four feet high in a space that
soars to eighty. They chose to symbol-
ize the passion of Christ with powerful
forms cast in precious metals. The base,
cross, and square backing were designed
by Osman and cast in solid silver. Based
largely on the sculptural language devel-
oped in France during the 1930s by the
Swiss modernist Alberto Giacometti,
these forms contain Sutherland's contri-
bution: a silver heart that supports a tiny
representation of Christ's body cast in
solid gold (see fig.). The central heart
is "framed" by four oxidized squares
representing the apostles, each of which
has three trinitarian "fingers" of gold
that seem to reach toward the body of
Christ. Nothing in the sculpture is literal
or strictly representational, and each
element was carefully conceived by the
artists, who followed the principles of
abstraction from natural forms conjoined
with those of Christian symbolism.

The cross took three years to design
and cast. Before being presented to Ely
Cathedral in 1964, it was sent on tour to

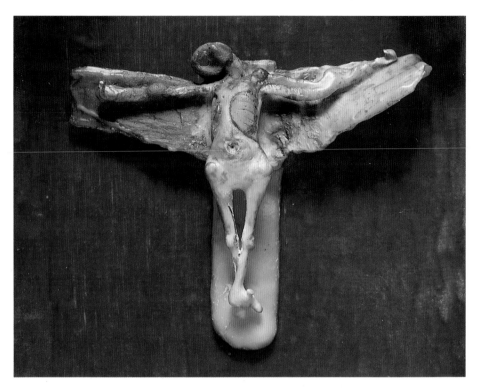

Graham Sutherland, *The Body of Christ* (maquette for *The Cross of Ely*). Wax, H. 5⅝ in. (14.3 cm), W. 6⅞ in. (17.5 cm), D. 1⅜ in. (3.5 cm). Dallas Museum of Art, The Wendy and Emery Reves Collection, 1985.R.70.

Australia, where it was a prominent part of a major survey of contemporary British art. The cross was very well received in Australia, but upon its installation on the high altar for the induction of a new Bishop of Ely, its failures became evident. Despite all the time and good intentions, the cross did not function as a viable visual form at Ely, and with considerable embarrassment, the dean of the Cathedral rejected the cross as "unsuitable and too expensive" (*Daily* 1965). Indeed,

only £700 had been raised for the cross, the actual cost of which had mounted to more than seven times that figure. Reluctantly, the Goldsmiths' Company, which had fabricated the cross, took it back and refunded the £700 to the Friends of Ely Cathedral. Wendy and Emery Reves, who were friends of Sutherland, purchased it directly from the Goldsmiths' Company in 1965 as an unusual addition to their growing collection of European sculpture.

Cross of Ely in situ, 1964. Ely Cathedral, Ely, Cambridgeshire, England.
Dallas Museum of Art archives.

GRAHAM SUTHERLAND
Portrait of Emery Reves, 1965–1966
Oil on canvas; 24½ × 20 in. (62.2 × 50.8 cm)
Not signed or dated
1985.R.73

COMMISSIONED PORTRAITS litter the history of art, but few of them play important roles. It is the rare ruler who had the luck, or brilliance, to be painted by van Dyck, as was Charles I, or by Velásquez, as was Philip IV. Napoleon fared well with David and Ingres, but one struggles to think of great portraits of important men and women produced in our century. Picasso's portraits of Ambroise Vollard and Gertrude Stein stand as exceptions to the rule of outright mediocrity.

Emery Reves made a calculated and brilliant choice of artists to create his portrait. The English artist Graham Sutherland was a good friend of Emery and Wendy Reves and lived not far from

Study for *Portrait of Emery Reves,* 1965. Oil on paper board, 10¾ × 8¾ in. (27.3 × 22.2 cm). Not signed or dated. Dallas Museum of Art, The Wendy and Emery Reves Collection, 1985.R.74.

them in the south of France. Yet, as we know, proximity between artist and sitter does not on its own create a successful portrait. What Sutherland knew of Reves was his sheer force of intellect, his unwavering attention, and his power of concentration, and all these qualities are embodied in his extraordinary likeness. He first studied Reves from life, doing small-scale models of the sitter's head and right hand. He elected to seize his sitter with an almost confrontational frontality, and the effect of this decision is that Emery Reves commands, and the viewer is forever caught in his gaze.

In the study, the head was drawn with a very limited palette, as Sutherland emphasized the strong linear qualities of Reves's eyebrows, furrowed brow, lips, and hair. The effect of rhythmic unity and gesture brings the rather formal frontal head to life. By placing the right hand near the face and stressing each finger, Sutherland gave Reves a suggestion of sensuality, which breaks the severity of his probing glance. To further

enliven the study, the artist placed the head in the upper right quadrant of the rectangle, and this asymmetry is carried even further in the finished portrait.

To complete his painting, Sutherland worked with Reves to imagine an appropriate setting and costume. Because Reves was as knowledgeable about clothing as he was about works of art, Sutherland portrayed him as casually elegant, wearing a soft, finely woven silk shirt, open at the collar, over which he sports a well-cut dark gray jacket. The contrast of white and black-gray in his clothing gives the work an understated simplicity. Interestingly, while Sutherland chose to depict Reves at his home, Villa La Pausa, with the iron grillwork of the patio reflected in a mirror just behind him, he did not allude in any way to Reves's passion for collecting. We see no bronzes, no wonderful porcelains, none of the superb inlaid furniture, and not a single painting or drawing. We are also ignorant of Reves's profession as a publisher and writer. Rather, Sutherland chose to represent his sitter simply as a cultivated man of power, caught forever between indoors and outdoors, between mirror and window. The wrinkles and lines of his face tell us about his age, his sufferings, and his history of living. Yet, his forthright glance tells us even more— that he is in control of his fate and that he judges us as we judge him. Few 20th-century portraits are as concise, as powerful, and as true.

References

AURIANT 1935
Jean Auriant. "Redon et E. Hennequin:
Lettres inédites." *Beaux-arts* (14 June 1935): 2.

BAREAU 1986
Juliet Wilson Bareau. "The Hidden Face
of Manet: An Investigation of the Artist's
Working Processes." *Burlington Magazine*
(April 1986): 1–98.

BARNES 1939
Albert C. Barnes and Violette de Mazia.
The Art of Cézanne. New York: Harcourt
Brace, 1939.

BAUDELAIRE 1961
Charles Baudelaire. *Oeuvres complètes.*
Y.-G. Le Dantec, ed. Paris: Gallimard,
Bibliothèque de la Pléïade, 1961.

BOUIN-LUCE 1986
Jean Bouin-Luce and Denise Bazetoux.
*Maximilien Luce: Catalogue raisonné de
l'oeuvre peint.* 2 vols. Paris: Editions JBL,
1986.

BRETTELL 1980
Richard Brettell and Christopher Lloyd.
*A Catalogue of the Drawings by Camille
Pissarro in the Ashmolean Museum, Oxford.*
New York: Oxford University Press, 1980.

CLARK 1956
Sir Kenneth McKenzie Clark. *The Nude:
A Study in Ideal Form.* New York: Pantheon
Books, 1956.

COOPER 1959
Douglas Cooper. "Renoir, Lise and the
Le Coeur Family: A Study of Renoir's Early
Development." *Burlington Magazine* (May
1959): 163–71.

Daily 1965
Daily Express, 28 May 1965. DMA object file
no. 1985.R.71.

DAUBERVILLE 1965
Jean and Henry Dauberville. *Bonnard:
Catalogue raisonné.* Paris: J. & H. Bernheim-
Jeune, 1965.

DAULTE 1959A
François Daulte. *Alfred Sisley: Catalogue
raisonné de l'oeuvre peint.* Lausanne:
Editions Durand-Ruel, 1959.

DAULTE 1959B
François Daulte. *Renoir: Watercolors and
Pastels.* New York: Abrams, 1959.

DELTEIL 1923
Loys Delteil. *Le Peintre-graveur illustré,
vol. XVII: Camille Pissarro, Alfred Sisley,
Auguste Renoir.* Paris: John Rewald, 1923.
Reprint, New York: DaCapo Press, 1968.

ELSEN 1985
Albert E. Elsen. *The Gates of Hell by Auguste
Rodin.* Stanford, Calif.: Stanford University
Press, 1985.

FERNIER 1977
Robert Fernier. *La Vie et l'oeuvre de Gustave
Courbet: Catalogue raisonné.* Fondation
Wildenstein. Lausanne and Paris: Biblio-
thèque des Arts, 1977.

VAN GOGH 1958
Vincent van Gogh. *Complete Letters.* 3 vols.
Greenwich, Conn.: New York Graphic
Society, 1958.

GOWING 1956
Lawrence Gowing. "Notes on the Develop-
ment of Cézanne." *Burlington Magazine*
(June 1956): 185–92.

HUYSMANS 1885
Joris-Karl Huysmans. "Le Nouvel album d'Odilon Redon." *La Revue indépendente* (1 Feb. 1885): 291–96.

LEMOISNE 1946
Paul A. Lemoisne. *Degas et son oeuvre.* 4 vols. Paris: Paul Brame and C. M. Hauke aux Arts et Métiers Graphiques, 1946–1949.

MAISON 1968
K. E. Maison. *Honoré Daumier: Catalogue Raisonné of the Paintings, Watercolors, and Drawings.* 2 vols. Greenwich, Conn.: New York Graphic Society, 1968.

MIRBEAU 1904
Octave Mirbeau. *Camille Pissarro.* Paris: Durand-Ruel, 1904.

PISSARRO 1989
Ludovic-Rodo Pissarro and Lionello Venturi. *Camille Pissarro: Son art, son oeuvre.* 2 vols. Paris, 1939. Reprint, San Francisco: Alan Wofsy Fine Arts, 1989.

REWALD 1961
John Rewald. *The History of Impressionism.* New York: Museum of Modern Art, 1946. Reprint, 1961.

REWALD 1978
John Rewald. Letter to Emery Reves, 17 July 1978. DMA object file no. 1985.R.13.

REWALD 1981
John Rewald, ed., with Lucien Pissarro. *Camille Pissarro: Letters to His Son Lucien.* Santa Barbara, Calif.: Peregrine Smith, 1981.

REWALD 1986
John Rewald. *Cézanne: A Biography.* New York: Harry N. Abrams, 1986.

RICH 1935
Daniel Catton Rich. *Seurat and the Evolution of La Grande Jatte.* Chicago: University of Chicago Press, 1935.

ROUART 1975
Denis Rouart. *Edouard Manet: Catalogue raisonné.* Lausanne and Paris: Bibliothèque des Arts, 1975.

TABARANT 1947
Adolphe Tabarant. *Manet et ses oeuvres.* Paris: Gallimard, 1947.

ZOLA 1866
Emile Zola. "Salon de 1866: Mon salon." *L'Evénement* (27 April 1866). Later published in *Emile Zola, Salons.* F. W. J. Hemmings and R. J. Niess, eds. Geneva: Droz, 1959.

Concordance of Proper Names

DR. ALBERT C. BARNES (1872–1951)
American drug manufacturer, art historian, and collector

CHARLES BAUDELAIRE (1821–1867)
French poet and critic

TRISTAN BERNARD (1866–1947)
French author and dramatist; married to Marcelle Aron, cousin of Lucie Hessel

LILLIE P. BLISS (DIED 1931)
American art collector; one of the seven founders of the Museum of Modern Art, New York, and a major donor to the collection

EUGENE BLOT (1830–1899)
French sculptor

LOUIS-LEOPOLD BOILLY (1761–1845)
French painter and engraver

RICHARD PARKES BONINGTON (1802–1828)
English landscape painter, active mainly in France

MARTHE BONNARD, NEE MARIA BOURSIN (1869–1942)
Model and, from 1925, wife of Pierre Bonnard

FRANÇOIS BOUCHER (1703–1770)
French rococo painter, engraver, and designer

GEORGES BRAQUE (1882–1963)
French painter; with Picasso, the creator of cubism

GEORGES BRIERE DE L'ISLE (1847–1902)
French architect; friend of Jules Le Coeur and husband of Lise Tréhot

ARISTIDE BRUANT (1851–1925)
French songwriter and cabaret proprietor; often portrayed by Henri de Toulouse-Lautrec

GUSTAVE CAILLEBOTTE (1848–1894)
French painter and collector

MARY CASSATT (1844–1926)
American painter and printmaker, worked mainly in Paris with the impressionists

LOUIS-AUGUSTE CEZANNE (1798–1886)
French hat dealer who became a prosperous banker in Aix-en-Provence; father of Paul Cézanne

ERNEST CHAPLET (1835–1909)
Haviland pottery factory director and renovator of modern French ceramics; taught Paul Gauguin glazing techniques

JEAN-BAPTISTE-SIMEON CHARDIN (1699–1779)
French still-life and genre painter

CHARLES I (1600–1649)
King of England and Scotland (1625–1649)

SIR WINSTON CHURCHILL (1874–1965)
British statesman, soldier, and author; prime minister (1940–1945 and 1951–1955)

JAMES CLARK (1909–1979) AND LILLIAN CLARK (BORN 1905)
Dallas art collectors and philanthropists

KENNETH CLARK, LORD CLARK OF SALTWOOD (1903–1983)
British art historian, administrator, patron, and collector

CAMILLE CLAUDEL (1856–1920)
French sculptor; model and mistress of
Auguste Rodin

JOHN CONSTABLE (1776–1837)
English landscape painter whose work
indirectly influenced the course of French
19th-century landscape painting

ROMAIN COOLUS, PSEUDONYM OF PIERRE-
EMIL WEILL (1868–1952)
French author and dramatist

DOUGLAS COOPER (1911–1984)
British art critic and collector

REGIS COURBET (born 1798)
Prosperous farmer of Ornans, France; father
of Gustave Courbet

PIERRE COURTHION (BORN 1902)
French art historian

DANTE (ALIGHIERI) (1265–1321)
Italian poet; author of the *Divine Comedy*

CHARLES-FRANÇOIS DAUBIGNY (1817–1878)
French landscape painter of the Barbizon
School

JACQUES-LOUIS DAVID (1748–1825)
French painter; one of the central figures of
neoclassicism

RENE DE GAS (1845–1927)
Brother of Edgar Degas

MEYER DE HAAN (1852–1895)
Dutch painter; friend and supporter of Paul
Gauguin

EUGENE DELACROIX (1798–1863)
Greatest French painter of the romantic
movement

JOHN DE MENIL (1904–1973) AND
DOMINIQUE DE MENIL (BORN 1908)
Houston collectors and philanthropists

ANDRE DERAIN (1880–1954)
French painter, sculptor, and graphic artist

JULIETTE DODU (1848–1909)
French author and half-sister of Camille
Redon, decorated for her courageous con-
duct during the Franco-Prussian War;
published under the pseudonym of Lipp
a novel entitled *L'Eternel Roman* in 1891

CAPTAIN ALFRED DREYFUS (1859–1935)
French general staff officer, an Alsatian Jew,
convicted of treason in 1894, later exoner-
ated and pardoned; center of the infamous
Dreyfus Affair, which polarized French pub-
lic opinion in the late 1890s

PAUL DURAND-RUEL (1831–1922)
French picture dealer; renowned as the first
dealer to give unwavering support to the
impressionists

SIR ANTHONY VAN DYCK (1599–1641)
One of the greatest Flemish painters of the
17th century, with Sir Peter Paul Rubens
(1577–1640)

ALBERT ELSEN (1927–1995)
American art historian

DR. THOMAS W. EVANS (DIED 1897)
Philadelphia physician, dentist, and art
collector; Evans practiced dentistry in
Paris, eventually becoming official Imperial
Surgeon-Dentist to Louis Napoleon

MAURICE FENAILLE (1855–1937)
French art historian

FELIX FENEON (1861–1944)
French critic and collector

ROBERT FERNIER (1895–1977)
French painter and art historian

JEAN-HONORE FRAGONARD (1732–1806)
French rococo painter; grandfather of
Berthe Morisot

DR. PAUL GACHET (1828–1909)
French physician and printmaker from
Auvers-sur-Oise; friend of the impressionists
and host to Vincent van Gogh in his final
days

MARGUERITE-CLEMENTINE GACHET
(1871–1949)
Daughter of Dr. Gachet, painted by Vincent van Gogh

ISIDORE GAUGUIN (DIED 1893)
Early guardian to nephew Paul Gauguin and niece Marie

POLA (PAUL ROLLON) GAUGUIN (1883–1961)
French author; fourth son of Paul Gauguin

THEODORE GERICAULT (1791–1824)
French romantic painter

ALBERTO GIACOMETTI (1901–1966)
Swiss sculptor and painter

THEO VAN GOGH (1857–1891)
Dutch manager of the Boussod-Valadon Gallery of modern art, Paris; early supporter of the impressionists and brother of Vincent van Gogh

SIR LAWRENCE GOWING (1918–1992)
British painter, art historian, and academician

FRANCISCO JOSE DE GOYA Y LUCIENTES
(1746–1828)
Spanish painter and graphic artist known for his brutal realism and social satire

JEAN-BAPTISTE GREUZE (1725–1805)
French genre and portrait painter

BENJAMIN GUINAUDEAU (BORN 1858)
French writer

EMILE HENNEQUIN (1858–1888)
French critic; supporter and correspondent of Odilon Redon

HENRI IV (1553–1610)
First Bourbon king of France (1589–1610), also King Henri III of Navarre (1572–1610); his gallantry, Gallic wit, and concern for the common people have made him perhaps the most popular of the French kings

JOSEPH HESSEL (DATES UNKNOWN)
Manager of Bernheim-Jeune gallery and an inveterate gambler; his wife, Lucie, promi-nent in Parisian society and a close friend of Edouard Vuillard, was called "Vuillard's Dragon" by Tristan Bernard

EDWARD HOPPER (1882–1967)
American painter and engraver; central exponent of American Scene painting

VICTOR HUGO (1802–1885)
French poet, dramatist, and novelist; author of *Notre Dame de Paris* (1831) and *Les Misérables* (1862)

JORIS-KARL HUYSMANS (1848–1907)
French critic and novelist of Dutch origin; friend of Odilon Redon and supporter of symbolism

JEAN-AUGUSTE-DOMINIQUE INGRES
(1780–1867)
French painter; best known for his imperial and society portraits in the neoclassical style

DR. LOUIS LA CAZE (DIED 1869)
French art collector; major donor to the Musée du Louvre, Paris

MERY LAURENT (1850–1900)
French actress; mistress of Dr. Thomas W. Evans, model and last sitter for Edouard Manet

JULES LE COEUR (1832–1882)
French architect turned painter; companion of Pierre-Auguste Renoir

MARGUERITE (MARGOT) LEGRAND
(DIED 1881)
French model for Pierre-Auguste Renoir; appears in paintings by Renoir including *Dance at the Moulin de la Galette* (1876, Musée d'Orsay)

HENRI LE SECQ (1818–1882)
French photographer; pioneer in architec-tural photography

CLAUDE (GELLEE) LORRAIN (1600–1682)
French painter; the most celebrated of all exponents of ideal landscape

STEPHANE MALLARME (1842–1898)
French poet; forebear of the symbolists

EUGENE MANET (1833–1892)
Husband of Berthe Morisot and brother of
Edouard Manet

ALBERT MARQUET (1875–1947)
French landscape painter

HENRI MATISSE (1869–1954)
French fauve painter, sculptor, artist, and
designer; master of calligraphic pattern and
the abstract use of pure color

MICHELANGELO (BUONARROTI) (1475–1564)
Florentine sculptor, painter, architect, drafts-
man, and poet; one of the dominant figures
of the Renaissance

JEAN-FRANÇOIS MILLET (1814–1875)
French painter and graphic artist of the
Barbizon School

HENRY MOORE (1898–1986)
English sculptor and graphic artist

GIORGIO MORANDI (1890–1964)
Italian still-life painter and etcher

WILLIAM MORRIS (1834–1896)
English writer, painter, designer, craftsman,
and social reformer

EUGENE MURER (1845–1906)
French painter, hotelier, and pastry cook
from Rouen and Auvers-sur-Oise; early
collector of impressionist works

BARTOLOME ESTEBAN MURILLO
(1617/18–1682)
Spanish painter of religious and genre scenes

NADAR, PSEUDONYM OF GASPARD-FELIX
TOURNACHON (1820–1910)
French pioneer photographer and writer;
host of the first impressionist exhibition

NAPOLEON (BONAPARTE) (1769–1821)
Emperor of France (1804–1814, 1815)

NATANSON FAMILY
Thadée (1868–1951) and his brother Alfred
were editors of *La Revue blanche* (founded
1891), one of the chief organs of expression
for artists of the avant-garde. Alfred was
married to Marthe Mellot, and Thadée was
the first husband of Misia Godebska (1872–
1950); both women were prominent in avant-
garde society and frequent models for
painters at the turn of the century

JEAN-ANTOINE OUDOT (DIED 1848)
French lawyer and veteran of the Revolution;
maternal grandfather of Gustave Courbet

AUGUSTE PELLERIN (1852–1929)
French collector

PHILIP IV (1605–1665)
King of Spain, Naples, and Sicily (1621–
1665), as Philip III, king of Portugal
(1621–1640)

PABLO PICASSO (1881–1973)
Spanish painter, sculptor, graphic artist,
ceramicist, and designer who was the most
famous, versatile, and prolific artist of the
20th century

JEAN-BAPTISTE-MARIE PIERRE (1714–1789)
French artist, First Painter of the King, and
director of the Royal Academy of Painting
and Sculpture

FELIX PISSARRO (1874–1897)
Third son of Camille Pissarro

GEORGES PISSARRO (1871–1961)
Second son of Camille Pissarro

LUCIEN PISSARRO (1863–1944)
French artist and eldest son of Camille
Pissarro

LUDOVIC-RODO PISSARRO (1878–1952)
Fourth son of Camille Pissarro and coauthor
of the catalogue raisonné of his father's work

NICOLAS POUSSIN (1594–1665)
French painter, active mainly in Rome; his
painting became the standard for classical
French painting

PIERRE-JOSEPH PROUDHON (1809–1865)
French anarchist philosopher

ANTONIN PROUST (1832–1905)
French author and collector; friend of
Edouard Manet

JOSEPH PULITZER (1847–1911)
Hungarian-born American newspaper
publisher, art collector, and endower of the
Pulitzer Prize

CAMILLE REDON, NEE FALTE (1853–1923)
Model and wife of painter Odilon Redon

PAUL REVERDY (DATES UNKNOWN)
French author; associate of cubist painters
and great-nephew of Gustave Courbet

JOHN REWALD (BORN 1912)
German-born American art historian and
professor; foremost authority on impres-
sionism and post-impressionism

DANIEL CATTON RICH (1904–1976)
Art historian and director of fine arts at the
Art Institute of Chicago

GEORGES RIVIERE (BORN 1855)
French critic and employee with the Ministry
of France; publisher of the journal *L'Impres-
sioniste* in 1877

HUBERT ROBERT (1733–1808)
French landscape painter; Keeper of the
King's Pictures for Louis XVI and one of the
first curators of the Musée du Louvre

DAVID ROCKEFELLER (BORN 1915)
American banker and collector

SIEGFRIED ROSENGART (1894–1985)
Swiss art dealer

HENRI ROUART (1833–1912)
French painter; friend of Edgar Degas and
Edouard Manet, and father-in-law of Manet's
niece Julie

EMILE SCHUFFENECKER (1851–1934)
French painter; an early supporter of Paul
Gauguin. His wife, Louise, was the subject of
several works by Gauguin

ANNETTE OCTAVIE SENNEGON, NEE COROT
(1793–1874)
Sister of Jean-Baptiste-Camille Corot; mar-
ried to Laurent Denis Sennegon of Rouen

GERTRUDE STEIN (1874–1946)
American author and patron of the arts, lived
mainly in Paris

ADOLPHE TABARANT (1863–1950)
French art historian

TERRASSE FAMILY
Claude Terrasse (1867–1923), a French musi-
cian, married Pierre Bonnard's younger
sister, Andrée; children Jean, Charles, and
Renée were often painted by Bonnard.
Charles Terrasse was curator of the museum
at Fontainebleau

CLEMENCE TREHOT (1843–1926)
Daughter of the last postmaster of Ecquivilly;
mistress of Jules Le Coeur, friend of Pierre-
Auguste Renoir and older sister of Lise

LISE TREHOT (1848–1922)
Fourth child of Louis Tréhot and Amélie
Elisabeth Boudin; model and mistress of
Pierre-Auguste Renoir from 1866 until 1872
when she married Georges Brière de l'Isle

HUGO VON TSCHUDI (1851–1911)
German art historian; director of the
Nationalgalerie in Berlin (1896–1909)

JOSEPH MALLORD WILLIAM TURNER
(1775–1851)
English landscape painter; the most original
romantic artist in the 19th century

LOUIS VAUXCELLES (BORN 1870)
French art critic; responsible for coining
terms "fauve" and "cubist"

DIEGO RODRIGUEZ DE SILVA Y VELASQUEZ
(1599–1660)
Most celebrated painter of the Spanish
School

JULIE VELLAY (1838–1926)
Daughter of Burgundian vine grower and
wife of Camille Pissarro

LIONELLO VENTURI (1885–1961)
Italian teacher and writer of art history;
coauthor of catalogue raisonné of Camille
Pissarro's work

HENRI VEVER (1854–1942)
French art collector

DR. GEORGES VIAU (1855–1907)
Parisian art collector

AMBROISE VOLLARD (1867–1939)
French art dealer, collector, and publisher;
noted for his early sponsorship of Vincent
van Gogh, Paul Cézanne, Henri Matisse,
and Pablo Picasso

JEAN-ANTOINE WATTEAU (1684–1721)
French rococo painter of Flemish descent;
adept painter of theatrical life in 18th-century
Paris

JAMES ABBOTT MACNEIL WHISTLER
(1834–1903)
American-born painter and graphic artist,
active mainly in England

EMILE ZOLA (1840–1902)
French novelist, journalist, and social
critic; author of *Thérèse Raquin* (1867),
L'Assommoir (1877), and *Nana* (1880) and
supporter of avant-garde movements in art